M000111622

# KANSAS UNIVERSITY
## BASKETBALL LEGENDS

KENNETH N. JOHNSON, PHD

FOREWORD BY BILL MAYER

THE
History
PRESS

Published by The History Press
Charleston, SC 29403
www.historypress.net

Copyright © 2013 by Kenneth N. Johnson, PhD
All rights reserved

First published 2013

Manufactured in the United States

ISBN 978.1.62619.375.8

Library of Congress CIP data applied for.

*Notice*: The information in this book is true and complete to the best of our knowledge. It is offered without guarantee on the part of the author or The History Press. The author and The History Press disclaim all liability in connection with the use of this book.

All rights reserved. No part of this book may be reproduced or transmitted in any form whatsoever without prior written permission from the publisher except in the case of brief quotations embodied in critical articles and reviews.

*Dedicated to my father, A. Ted Johnson (1909–2004)*

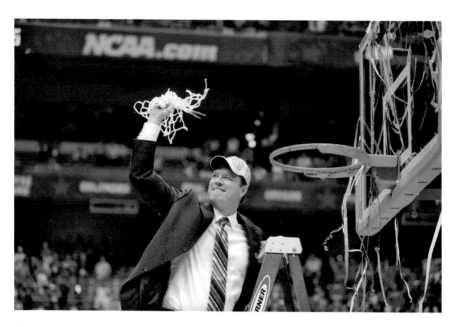

Bill Self cutting down the net. Lawrence Journal-World *photograph by Thad Alexander.*

*Because sometimes you need a biologist,*
*and sometimes you need a poet.*
*Sometimes you need a scientist,*
*and sometimes you need a song.*
*—Rob Bell*

*But sometimes you just need a good book on basketball.*
*—Kenn Johnson*

# CONTENTS

# CONTENTS

# FOREWORD

Even deeply dedicated and highly informed Kansas University basketball fans may be enlightened and even humbled after they read Kenn Johnson's *Kansas University Basketball Legends.* They will be amazed at what they don't know about this phenomenal entity and will quickly be stimulated to play catch-up—with the Johnson volume providing them with all they need.

The other side of the coin is that neophyte Jayhawk zealots, who might not know much at all on the subject yet want to be part of the picture, will have in their hands an instrument that can do a better job than anything else they can find to initiate them into the Jayhawk cult. Johnson's offering is the most complete piece on this subject that I encountered in my sixty years as an active newspaperman with the *Lawrence Journal-World. Legends*, with its vast span of expertise, is a reference work that nobody else, to my knowledge, has ever come close to duplicating. Devoted to statistics and history, Johnson uses them, along with his devotion to KU and its court achievements, to turn out a publication that is not only informative and entertaining but also offers a depth and scope of his subject that is well organized and a treat to read. He lays his vast material on the line in a way that clearly reflects his love for KU basketball while offering the material with obvious pleasure.

You get the idea he had a lot of fun compiling it all. The material ranges from basketball's early days at KU, with icons such as James Naismith and Phog Allen, into the current era, right up to the 2012 season.

Coaches, players, officials, administrators and others who helped fashion what KU can point to with intense pride are cited and described. Even the

most loyal Jayhawk will be surprised at all he or she doesn't know. Kansas basketball has been so superlative that many an outstanding personality may occasionally have been lost in the shuffle of public attention. Johnson helps us understand this and, frankly, offers stories that might well have been overlooked but for Kenn's keen perception.

Get ready for a treat! But beware. Many may get so addicted to trying to absorb this material that their book's pages will become worn and grubby from the incessant reading and re-reading to gain enlightenment about KU's phenomenal basketball history.

BILL MAYER, SPORTSWRITER
*LAWRENCE JOURNAL-WORLD*

# PREFACE

When I was ten years old in 1951, my dad and I drove from western Kansas to Lawrence to see the Jayhawks play. I was becoming a fan, listening to most of their games on radio—TV didn't reach out that far then, and newspaper coverage was slim, to say the least. The Jayhawks played in Hoch Auditorium, and its small capacity was overflowing—with people and excitement. Big Clyde Lovellette and Dean Kelley were the stars that night as they won, on their way to a 16-8 record. The next year, they won the NCAA national championship and went on to the Olympics! I was hooked forever as a KU basketball junkie.

This book is the fruit of a longstanding love affair I have had with basketball since I was a young boy. Now, I'm a short, old, slow guy who has been eternally cursed/blessed with a love for a game for tall, young, fast guys. I was born in Ashland, Kansas, in 1941 and later moved to Topeka, Kansas, where I attended Topeka High School (class of '59) and Washburn University (BBA '67). In between, I spent three years in Europe, courtesy of the U.S. Army. I then went to graduate school at KU, getting a master's degree in business administration in 1970.

Over the years, I have had the opportunity to see the Jayhawks up close. While I was in high school, Wilt Chamberlain starred for KU. JoJo White starred when I was in graduate school at KU and Danny Manning excelled while both my daughters attended Kansas. My oldest daughter was in the same class as Manning and the youngest two years behind. So, from '84 through '90, I spent a lot of time in Lawrence. Both daughters married

Jayhawkers and have given us six thoroughbred Jayhawk grandchildren. Now a prominent lawyer, one son-in-law starred on the KU diving team, and the other served as backup quarterback on the KU football team from 1987 to 1989 (he had the misfortune of being there at the same time as Kelly Donaho). He's now the head football coach at Holland Hall High School in Tulsa.

I have made every effort to determine the copyright holder for every source used in researching this publication. Nonetheless, there are certain sources for which I could not ascertain all of the appropriate references. And I may have inadvertently and unknowingly plagiarized somewhat. In such cases, let me apologize here to any such authors.

# ACKNOWLEDGEMENTS

Over the years, I have spent many hours in the Kansas University Archives collecting information for this book. My thanks go to Ned Kehde and his staff, who were always willing and able to point me in the right direction and were extremely helpful.

First and foremost, though, my thanks go to the several KU Legends highlighted in this book for their editing suggestions and encouragement.

Without question, considerable credit also goes to Becky Lejeune and the rest of the team at The History Press for their patience, guidance and desire to make this book the best possible and getting it out in time for the 2013 basketball season.

Many thanks also:

To Bill Mayer of the *Lawrence Journal-World*, whose knowledge of KU basketball history and his advice and encouragement over the years have helped immeasurably in bringing this work to publication.

To Becky Schulte and Kathy Lafferty, of the Spencer Research Library at KU, for all their help with providing a considerable number of images used in this book, as well as Doug Vance, Chris Theisen and others in the KU Athletic Department for their help in getting approval to use a number of the images in this book.

To Mike Yoder, Gary Bedore, Ralph Gage Jr. and Alma Bahman of the *Lawrence Journal-World*, one of my main sources of information and images of KU basketball.

To my wife, Colleen, and son, Eric, who have put up with me and provided encouragement at key times in the book's development.

# ACKNOWLEDGEMENTS

To my daughters, Heidi and Cassity, and their husbands, Denny and Tag, all of whom graduated from KU, for their love and support and some occasional editing advice.

# NONPAREILS

*Nonpareil (nŏn'pə-rĕl')*
*adj. Having no equal; peerless*
*n. A person or thing that has no equal; a paragon.*

Two Legends associated with the University of Kansas basketball program are truly incomparable to all others: Dr. James Naismith, basketball's inventor and first coach at KU, and Wilt Chamberlain, arguably the finest basketball player ever. Both were unique and are deserving of their recognition as paragons in the entire history of basketball.

## DR. JAMES A. NAISMITH (COACH: 1898–1907): THE ORIGINAL KU LEGEND

The "Father of Basketball," Dr. James Naismith, invented the game in Springfield, Massachusetts, in December 1891. At the time, he was a physical education instructor at Springfield College, a training school of the Springfield YMCA. Naismith was asked by Dr. Luther Gulick, head of Springfield YMCA Physical Education, to come up with a game that would occupy students' time and give them exercise during the winter, in between football and baseball seasons.

## *Inventing the Game*

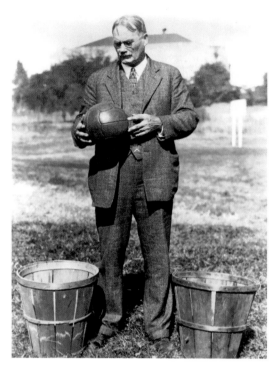

Dr. James Naismith. *KU Spencer Research Library.*

Naismith desired to develop an indoor sport that required finesse and skill rather than strength. First, he analyzed the popular games of those times (rugby, lacrosse, soccer, football, hockey and baseball) and was guided by three main ideas. He noticed the hazards of a small, fast ball and concluded that the big, soft soccer ball was safest. Secondly, he saw that most physical contact occurred while running with the ball, or hitting it, so he decided that passing was a better option. Finally, Naismith further reduced body contact by making the goal unguardable—namely, placing peach baskets high above the players' heads. To score goals, he forced the players to throw a soft, lobbing shot that had proven effective in his favorite old game, duck on a rock, which involved throwing balls into empty boxes. Naismith christened this new game "Basket Ball" and put his thoughts together in thirteen basic rules. Miss Lyons, the school stenographer, typed them on two sheets of paper. They are now enshrined in Allen Field House on the KU campus.

Nine players on a side handled a soccer ball, and the goals were a pair of peach baskets:

> *When Mr. Stubbins, the Superintendent of Buildings, brought up the peach baskets to the gym, I secured them on the inside of the railing of the gallery. This was about 10 feet from the floor, one at each end of the gymnasium. I then put the 13 rules on the bulletin board just behind the instructor's platform, secured a soccer ball and awaited the arrival of the class. I then*

*explained what they had to do to make goals, tossed the ball up between the two center men and tried to keep them somewhat near the rules.*

In stark contrast to modern basketball, the original rules did not include the dribble. Since the ball could only be moved up the court via a pass, early players tossed the ball over their heads as they ran up court. Also, following each "goal," a jump ball was taken in the middle of the court.

## Personal Life

Naismith was born in 1861 on a small family farm in rural Canada, the oldest child of Scottish immigrants John and Margaret Naismith. Unfortunately, his parents contracted typhoid fever and both died when he was nine years old. James and his brother and sister spent the next two years living with their maternal grandmother. When their grandmother also died in 1873, the Naismith children were left under the care of their uncle. At the age of ten, James went to work in the lumber camps and surrounding farms to help support the family. At fifteen, he saw no need to stay in school and dropped out of Almonte High School in Ontario for four years but returned to graduate in 1883. Shortly thereafter, he was accepted at McGill University. While at McGill, he developed a passion for sports that lasted the rest of his life. He was a talented and versatile athlete and was excellent at many sports. After graduation, he enrolled in Presbyterian College, a theological school affiliated with McGill University.

## Early Professional Life

After graduating, James accepted a position at the YMCA in Springfield, Massachusetts, where he stayed for five years. On June 20, 1894, Naismith married Maude Sherman from Springfield. The next year, he accepted a similar position at the YMCA in Denver, Colorado. While there, he worked and attended Gross Medical School at the University of Colorado. Naismith was an intense student, collecting four degrees in the diverse fields of philosophy, religion, physical education and medicine.

## Coming to Kansas

It wasn't basketball that brought Naismith to Lawrence in 1898. KU chancellor Francis Snow needed somebody to lead prayer in the chapel where daily attendance was required. Snow contacted University of Chicago football coach Amos Alonzo Stagg. Naismith and Stagg played football together for the Stubby Christians of Springfield College, and Stagg quickly fired back, "James is a medical doctor, Presbyterian minister, Tee-totaler, all-around athlete, nonsmoker, and owner of a vocabulary without cuss words." Snow hired Naismith as director of physical education, at $1,300 per year, thus beginning his thirty-nine-year career at the University of Kansas, from which he retired in 1937.

## Kansas's First Basketball Coach

Naismith organized basketball at Kansas, and interest grew rapidly. A tournament was held to select the first team, and on February 3, 1899, Kansas played its first game against the Kansas City YMCA, losing 16–5. Naismith, as he would for many Kansas games, served as the referee. The Jayhawks won six straight games after that loss, including a rematch with the KC YMCA team in Lawrence, finishing the season 7-4. There wouldn't be another winning season until 1905–06, when a sophomore named Forrest C. Allen was the star player.

Naismith's career mark of 55-60 makes him the only coach in KU's history with a losing record. But Naismith didn't consider himself a coach. He officiated many of the games—that's why he accompanied the team on the road. He usually didn't attend practices. In a 1914 speech to the eighth annual NCAA convention, Naismith said that the ideal basketball player was "primarily a gentleman, secondarily a college man, and incidentally a basket ball player." Naismith thought of himself as primarily a doctor, secondarily an educator and never as the Jayhawks' basketball coach.

He preferred the term "teaching"—like the time when Baker University wrote to him to inquire about hiring a young KU athlete to be its basketball coach. Naismith called in his student and successor, Phog Allen, to announce the news. "I've got a joke on you," Naismith said with a laugh. "They want you to coach basketball down at Baker."

Phog bristled. "What's so funny about that?"

"Why, Forrest, you don't coach basketball, you just play it!"

Being a minister and doctor by training, Naismith was more an advocate of spiritual and mental fitness than a teacher of technique. "So much stress

is laid today on the winning of games," he wrote in 1914, "that practically all else is lost sight of, and the fine elements of manliness and true sportsmanship are accorded a secondary place."

Naismith handed over the team to Allen in 1907. He remained in the Physical Education Department at Kansas for the next three decades and died in 1939, two years before the Naismith Memorial Hall of Fame opened in Springfield. He had the thrill of seeing basketball grow from his idea in 1891 to an international sport at the 1936 Berlin Olympics, when the sport was included in the Olympic program for the first time. In 1935, the National Association of Basketball Coaches collected money so that the seventy-four-year-old Naismith could witness the introduction of basketball into the official Olympic sports program of the 1936 Summer Olympic Games. Dr. Naismith arrived in Germany without even a pass to see the game and was almost turned away at the gate. However, the American Olympic Committee's efforts managed to get him a pass for all the games. Naismith tossed up the first ball in the opening game between France and Estonia. Among his observations: the Chinese were the best ball handlers, and Poland played the best game. Fittingly, the United States played Canada for the gold medal, and Naismith watched his adopted nation defeat his homeland.

During his tenure at KU, James took two extended leaves of absence. The first was in 1916, when, at the age of fifty-five, he volunteered to ride with General Pershing on the Mexican border of Texas during the war with the Mexican general Pancho Villa and his troops. The second was in 1917, when he volunteered to fight in France as a military chaplain in World War I. At the war's end, Naismith was nominated YMCA secretary and served a nineteen-month post in France before returning to Kansas University in 1919.

## *Inventor, Not an Entrepreneur*

Interestingly, basketball wasn't Naismith's first attempt at devising something to reduce or prevent injury. Boxed ears suffered while playing football in the 1880s prompted Naismith to design and wear a cut-up rugby ball fitted over his head, with flaps covering his ears. Thus, Naismith is recognized as the inventor of the football helmet, as well as the game of basketball—neither of which he ever patented.

Money was never his motivation. *Time* magazine once noted that Dr. James Naismith was "shrewd enough to invent the game of basketball, but not shrewd

Dr. James Naismith. *KU Spencer Research Library.*

enough to exploit it." In other words, Naismith never made a cent on the sport that has made millions of dollars for so many others. A cigarette company once offered him a lucrative contract to endorse smoking, but he didn't approve of smoking so turned it down. He died with his house still mortgaged.

## *Legacy*

Today, Naismith is recognized in Lawrence in several ways. Naismith Drive leads to Allen Field House. Naismith Hall is where many Kansas athletes reside. Naismith and his wife, Maude, are buried at Lawrence Memorial Park, and a large Naismith Memorial greets visitors at the entrance. Appropriately, he's depicted holding school textbooks in one arm and a basketball in the other. The university also named the court in Allen Field House the *James Naismith Court* in his honor.

He is a member of the Canadian Basketball Hall of Fame, the Canadian Olympic Hall of Fame, the Canadian Sports Hall of Fame, the Ontario Sports Legends Hall of Fame, the Ottawa Sports Hall of Fame, the McGill University Sports Hall of Fame, the Kansas State Sports Hall of Fame and the FIBA Hall

of Fame. And of course, the Naismith Memorial Basketball Hall of Fame carries his name.

Posthumously, his masterwork *Basketball—Its Origins and Development* was published in 1941. Other books he published are *Rules for Basket Ball* and *Basketball's Origins: Creative Problem Solving in the Gilded Age.*

On December 10, 2010, his original rules of basketball were auctioned for $4.4 million at Sotheby's in New York. The rules were purchased by David G. Booth, an alumnus of the University of Kansas, with the stated purpose of housing the 119-year-old document on KU's campus. The proceeds will benefit the Naismith Foundation, which promotes sportsmanship and provides services to underprivileged children around the world. Ian Naismith, the foundation's founder and grandson of James Naismith, told the Associated Press in an interview in October that it was a family decision to put the rules on the auction block and give the money to the Naismith charity.

*Naismith once was asked by Allen why basketball was so popular. Naismith responded,*
*"The appeal of basketball is that it is an easy game to play but difficult to master."*
*Allen asked, "You mean, just like life?"*
*Naismith responded, "Yes, just like life, Forrest."*

# WILTON NORMAN "WILT" CHAMBERLAIN
# (PLAYER: 1957–58)

*The world is made up of Davids, and I am Goliath.*
*—Wilt Chamberlain*

*We will never see another one like him.*
*—Kareem Abdul-Jabbar*

*Wilt was the greatest athlete of them all.*
*—Dick Vitale*

These quotes pretty well sum up Wilt "the Stilt" Chamberlain. So much was written about him (and by him), it's hard to believe that anyone does not already know about his prowess on the court, as well as his storied life off the court. Because he was so large in life, both on and off the court, one could

stop right here in developing this section. However, younger generations may not believe that his like existed.

I had the great opportunity to see Wilt up close while I was a student at Topeka High School during the late 1950s. THS had a great basketball team in 1957–58, thought to be the tallest high school team in the country, and KU was heavily recruiting our center, Fred Slaughter. Coach Dick Harp asked Wilt to come over to Topeka and add encouragement to Slaughter. I remember several times Wilt was in the stands at basketball games, usually spending most of the games signing autographs. It was at this time that his reputation with the ladies began to spread, and there were numerous rumors around school that he bedded a bunch of my schoolmates. No little "Wilties" were reported then, though—nor ever after.

During this time, I frequently saw KU play at Allen Field House or on TV. Wilt was clearly the best basketball player I ever saw, and I was simply stunned when he was able to traverse the entire length of the court in three or four bounds—stuffing the ball while leaving foes and teammates behind. It was unfortunate for him, and for basketball fans in general, that there was no shot clock, three-point line or wide lanes under the basket, as opposing teams quickly found that the best way to deal with the Jayhawks was to slow the game to a stall and put at least two, if not three, men surrounding Chamberlain. For example, KU's only two losses during the regular season in 1957 were to Iowa State (37–39) and Oklahoma State (54–56).

This kind of basketball was ultimately the reason Wilt left KU after his junior year. He criticized the defensive tactics used by KU's opponents when explaining his decision to leave in a 1958 article in *Look* magazine: "The game I was forced to play in college wasn't basketball. It was hurting my chances of ever developing into a successful professional player."

## *Early Years*

Wilt Chamberlain was born on August 21, 1936, in Philadelphia, one of nine children raised by William and Olivia Chamberlain. His father worked as a janitor for a local publishing company, while his mother performed outside housework. The Chamberlains lived in a racially mixed lower-middle-class neighborhood, and Wilt enjoyed a relatively pleasant childhood, with two brothers and six sisters. Both of his parents held strong beliefs in family values and the benefits of hard work. At the age of five, he started doing odd jobs around the neighborhood, like running errands, shoveling snow and

Wilt Chamberlain in a KU jacket. *KU Spencer Research Library.*

cleaning cellars, to help his parents pay the bills. The milkman who hired him when he was seven was under the impression that he was twelve.

Wilt was an average-sized baby, but by age fourteen he had sprouted to six-foot-eight, growing four inches in two months. Given his size, one might guess that his family members were tall, but that wasn't the case. Indeed, none of the other Chamberlain children exceeded five-foot-nine in height. However, Wilt was a frail child, nearly dying of pneumonia in his early years and missing a whole year of grade school as a result.

In athletics, Wilt was more interested in track and field but began to play on the basketball team at Shoemaker Junior High School, even though at the time he thought it was a game for "sissies." He also played on the playgrounds against older players, who taught him a lot about the game, which he came to love.

Already six-foot-ten in 1952, Chamberlain enrolled at Overbrook High School, where he became an outstanding high jumper, ran the 440 dash, shot the put and broad jumped. But according to Chamberlain, "basketball was king in Philadelphia," so he was encouraged to focus on basketball because of his natural height advantage. He soon became renowned for his scoring talent, his physical strength and his shot-blocking abilities.

According to ESPN journalist Hal Bock, Chamberlain was "scary, flat-out frightening...before he came along, most basketball players were mortal-sized men. Chamberlain changed that."

## *High School*

Photographs of Wilt in high school show a slender boy who, at six-foot-eleven, towered above the other players. He could stand flat-footed under the basket and almost touch the rim. Wilt averaged thirty-one points as a sophomore and led the Overbrook Panthers to the Philadelphia Public League title and a berth in the city championship game. In that game, West Catholic triple-teamed Chamberlain the entire game, and despite his twenty-nine points, the Panthers lost 42–54, ending their season at 19-2.

During his junior year, the Panthers comfortably won the Public League title and later won the city title by defeating South Catholic, 74–50. Wilt scored thirty-two points, leading Overbrook to a flawless 19-0 season. His coaches there took full advantage of his gifts. For example, the team would practice missing free throws so that Chamberlain could grab them and score field goals.

During summer vacations, Chamberlain worked as a bellhop in an affluent Jewish hotel in the Catskills. Red Auerbach, the coach of the Boston Celtics, spotted the talented teenager there and had him play one-on-one against KU standout and national champion B.H. Born, elected the Most Valuable Player of the 1953 NCAA Finals. Chamberlain won, 25–10. Born was so dejected that he gave up a promising NBA career and became an engineer ("If there were high school kids that good, I figured I wasn't going to make it to the pros").

It was also during this time that one of Wilt's nicknames, "the Stilt," was coined by a local newspaper writer. Chamberlain detested it, as he did other monikers that called attention to his height, such as "Goliath." The name he didn't mind was "Dipper," along with the later variant, "Big Dipper." The story was that Chamberlain's buddies, seeing him dip his head as his walked through doorways, tagged him with that nickname, and it stuck.

He continued his high scoring in his last season at Overbrook, with a 44.5-point average, once logging 74, 78 and 90 points in three consecutive games. The Panthers won the Public League a third time, beating West Philadelphia 78–60, and in the city championship game, they met Western Catholic once again. Scoring 35 points, Chamberlain led Overbrook to an easy 83–42 win. After three years, Chamberlain had won Overbrook

two city championships, logged a 56-3 record and broken Tom Gola's high school scoring record, scoring 2,252 points, averaging 37.4 per game.

As a result, over two hundred universities recruited the basketball sensation. Among others, UCLA offered Chamberlain the opportunity to become a movie star, the University of Pennsylvania wanted to buy him diamonds and Panthers coach Mosenson was even offered numerous coaching positions if he could deliver the center. Jimmy Breslin wrote in the *Saturday Evening Post* that some of the recruiters were so aggressive that they were willing "to violate the Lindbergh kidnapping law to capture the Dipper for their school." However, Wilt wanted a change and did not want to go nearby in Philadelphia or New York, was not interested in New England, snubbed the South because of segregation and felt that the Far West basketball was weak. That left the Midwest.

Kansas and Indiana pursued Wilt the most aggressively. They were intense rivals, and KU's Phog Allen and Indiana's Branch McCracken despised each other. McCracken was so convinced that Chamberlain was going to be a Hoosier that he even announced it publicly. In the end, though, Wilt chose the University of Kansas because of the recruiting by Hall of Fame coach Phog Allen. "Of course I used everything we had to get him," admitted Allen when asked what tricks he used to attract Chamberlain. "What do you think I am, a Sunday school teacher?"

Even the pros were after Chamberlain, but the rules then permitted eligibility only after graduating from college. If the rules had permitted it, he would have been able to join the NBA right out of high school. Eddie Gottlieb of the Philadelphia Warriors tried to persuade Wilt to go to college in the Philadelphia area so the Warriors could claim him in a territorial draft, and Red Auerbach of the Celtics tried to get him to go to a New England school. After the rule was changed to extend the territorial draft to high school, Gottlieb then selected Chamberlain in the 1955 draft, even though he would not be eligible to play for four more years.

Some observers were skeptical about why he traveled so far from his home base. But there were sound reasons for Chamberlain to enroll at Kansas. At the time, any young player interested in improving his basketball fortunes would consider KU because of its long and rich winning tradition under the famous Phog Allen, builder of thirty-one conference title teams and three national titles in forty-six years. And the cage facilities were outstanding, with the recent erection of Allen Fieldhouse in 1955.

Phog also turned his charm on Wilt's mother ("Mrs. Chamberlain, now I see why Wilt is such a nice boy"). They were all enough impressed that

Chamberlain announced his choice late in May. The ever-humorous Allen, upon being informed by the press that Wilt had announced he was going to college at KU, commented, "I hope that he will go out for basketball."

## *Freshman Year*

In his freshman track season, Wilt set the Big Seven freshman indoor record in the high jump, placed fourth at the Kansas Relays in the triple jump and captured third in the Big Seven at the shot put. Chamberlain's fellow students immediately embraced him. He was dean of his pledge class in the Kappa Alpha Psi fraternity.

NCAA rules at the time barred freshmen from playing at the varsity level, so when Chamberlain arrived at KU in September 1955, he played on the freshman basketball team under coach Allen, whom he greatly admired. Announced as 240 pounds, able to reach nine feet, six inches up in the air flat-footed and with a wingspan of seven feet, two inches, his first appearance was highly anticipated, and he delivered. In his debut game, the freshmen Jayhawks were pitted against the varsity.

With "the Stilt" as the obvious draw, fourteen thousand fans paid to watch the contest in the brand-new Allen Fieldhouse. The varsity Jayhawks, including two bona fide All-Americans in Captain Dallas Dobbs and Gene Elstun, had been named preseason favorites for winning the Big Seven championship, but with Wilt dominating the play throughout, the varsity bowed for the first time in the series that was started in 1922. Chamberlain later reminisced about the game in the *Philadelphia Daily News*: "We whipped 'em, 81–71. I had 40 or 42 points, about 30 rebounds, about 15 blocks. I knew I had to show them either I could do it or I couldn't."

## *Sophomore Year*

Unfortunately, Chamberlain's prospect of playing under Phog Allen ended when the coach turned seventy and was forced by the Kansas legislature to retire according to KU regulation before the 1957 season started. Undoubtedly, Wilt chose Kansas intending to play under the legendary coach, and it is questionable whether Chamberlain would have selected KU if he had known that Allen was going to retire. He was upset and nearly left Kansas, but he admired successor Dick Harp, and

they had their moments. But Wilt later made it clear he believed Phog would have led KU to the 1957 NCAA title that Kansas lost in triple overtime to North Carolina.

Chamberlain made his varsity debut on December 3, 1956. In his first game, the center scored fifty-two points and grabbed thirty-one rebounds, breaking both all-time school records in an 87–69 win against Northwestern. His teammate Monte Johnson testified how athletic he was: "Wilt had unbelievable endurance and speed and was never tired. When he dunked, he was so fast that a lot of players got their fingers jammed between Chamberlain's hand and the rim."

By this time, Chamberlain had developed several offensive weapons that became his trademarks: his finger roll; the fade-away jump shot, which he could also hit as a bank shot; his passing; and his shot blocking. Leading a talented squad of starters—Maurice King, Gene Elstun, John Parker and Lew Johnson—the Jayhawks went 12-0 until they lost a game in the last second, 37–39, against Iowa State in which the Cyclones continuously held the ball until eventually having a clear sight to the basket, a technique still possible in the days before the shot clock was introduced in 1984.

In its next game, KU beat ISU 75–64 in Lawrence in a game much more suited to the Jayhawks' tempo. After four more wins, KU lost a non-conference game, 56–54, to Oklahoma State, again on a last-second shot. Oklahoma State passed 160 times before taking a shot, a tactic Chamberlain understood but did not consider "basketball." But the Jayhawks were developing into a championship-caliber team. After closing out the conference season with four more victories to finish 11-1 and clinch the Big Seven title, KU headed to the NCAA regional in Dallas.

In 1957, before the current sixty-five-plus team tournament format was introduced, twenty-three teams played for the NCAA title. The Midwest regional tourney was held in Dallas, which at the time was segregated. In the first game, the Jayhawks played the all-white Southern Methodist Mustangs, which had won thirty-five straight games at home. KU player John Parker later said, "The crowd was brutal. We were spat on, pelted with debris, and subjected to the vilest racial epithets possible." In overtime, KU won 73–65 against SMU, and police had to escort the Jayhawks out to prevent the angry crowd from hijacking the team bus. The next game against Oklahoma City was equally nasty, with KU winning 81–61 under intense racial abuse. At the Final Four in Kansas City, KU made quick work of San Francisco, winning 80–56, to set up the championship game against number-one-ranked North Carolina.

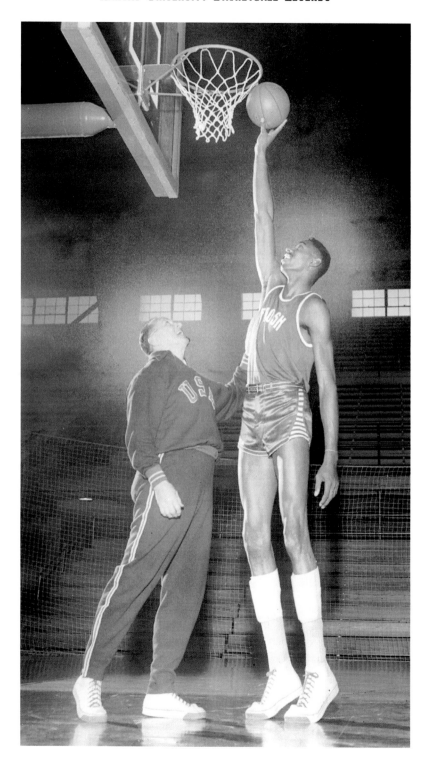

On March 23, 1957, KU and North Carolina met in one of the most thrilling championship games in NCAA history. In that game, Tar Heels coach Frank McGuire used several unorthodox tactics to thwart Chamberlain. At the tip-off, he sent in his shortest player, Tommy Kearns, in order to rattle him, and the Tar Heels spent the rest of the night triple-teaming Chamberlain, one defender in front, one behind and a third arriving as soon as he got the ball. Perhaps due to the extreme fixation on Chamberlain, the Jayhawks shot a miserable 27 percent from the field, as opposed to 64 percent for the Tar Heels, and trailed 22–29 at halftime. Later, North Carolina led 40–37 with ten minutes to go and began a stall. After several Tar Heel turnovers, the game was tied 46–46 at the end of regulation.

In the first overtime, both teams scored two points each, and in second overtime, Kansas froze the ball in return, keeping the game tied at 48–48. With six seconds remaining in the third OT, the Tar Heels led the Jayhawks 54–53. KU had the ball out of bounds at half court, and everyone knew what was coming: Wilt was going to get the ball. Parker threw the ball in to Loneski, who dribbled a couple of times before throwing a soft pass high to Chamberlain. But North Carolina center Joe Quigg jumped in front of Chamberlain and deflected the ball to teammate Kearns, who heaved the ball high into the rafters as the buzzer sounded.

Nevertheless, Chamberlain, who had scored twenty-three points and had fourteen rebounds, was elected the Most Outstanding Player of the Final Four. In his autobiography, he later wrote about the game: "I've always been more bitter about that loss than almost any other single game in my whole college and professional career."

With 800 points (a 29.6 average) and 510 rebounds for the season, Wilt was the dominant college player of his time. He was a unanimous all-conference and All-American choice. During the year, Chamberlain had a harried schedule. He averaged two national media interview sessions a week and appeared on TV's *The Ed Sullivan Show.* In order to appear with the Associated Press All-America team, he rushed to Kansas City after scoring forty points in KU's final conference game, flew to New York and then flew back in time for classes on Monday. He repeated the trip after the NCAA championship game to make an appearance with the Look All-America team.

*Opposite*: Wilt Chamberlain and Coach Allen. *KU Spencer Research Library.*

After a workout later that spring, Al Oerter (KU's All-American and Olympic discus thrower) saw the roly-poly Abe Saperstein, the Harlem Globetrotters owner, appear in the locker room at the KU arena. He said he heard Saperstein offer Chamberlain one-third ownership of the Globetrotters if he signed with the team at that moment. Eavesdropping, Oerter heard the Dipper say he wasn't interested, at least not yet.

On May 6, 1957, Phog Allen was quoted in a wire story as saying that Wilt would "definitely" turn pro and not return for his junior season: "Why, Wilt made more than $100,000 for the University of Kansas last year. He thinks it is time he made a little for himself." The same day, Chamberlain said he found the comments interesting: "It would appear that Phog knows more about my business than I do." All Chamberlain would add was: "Nobody knows what may happen between now and September."

## *Junior Year*

But Chamberlain did return for his junior season at KU. He was again selected all-conference and All-American, but his veteran supporting cast of Elstun, King, Johnson and Parker had graduated. Even with Wilt's average of 30.1 points a game (still a KU record for a single-season average), KU finished 18-5 overall (losing three games when he was out with a urinary infection) and 8-4 for a second-place tie in the conference. Because KU came in second in the league at the time when only conference winners were invited to the NCAA tourney, the Jayhawks' season ended.

The Jayhawks' matches were frustrating for Chamberlain. Teammate Bob Billings commented, "It was not fun basketball...we were just out chasing people throwing the basketball back and forth." In addition, Chamberlain grew weary of the punishment inflicted on him. After a game against Missouri, he showed imprints of two rows of teeth in his arm.

But the season was not without its highlights. On February 8 in Lawrence, KU met Nebraska, which was stuck in the league cellar. Behind Chamberlain's forty-six points, which broke B.H. Born's conference record of forty-four, the Jayhawks beat the Cornhuskers 104–46. The total broke KU's previous scoring record of one hundred points, set against Rice in the 1954–55 season. And in the final game of the season, KU met K-State, the conference champion and number-one-ranked team in the nation. In his final game as a Jayhawk, Wilt scored twenty-four points as KU controlled the game throughout, beating the Wildcats 61–44 in Manhattan.

Wilt, who was a radio and TV major, had his own radio show, *Flip'er with the Dipper*, on the student radio station. The thirty-minute show featured rhythm and blues music.

Because of Chamberlain's height and offensive prowess, NCAA administrators instituted several rules changes to limit his impact. The most important new regulation was offensive goaltending. Under the new rule, players could no longer guide the ball in or out of the basket by touching it while it was in the "cylinder," the space directly above the rim. Other new rules prohibited lobbing the ball over the backboard from behind it (so that a teammate could catch and dunk the ball) and taking a running leap from the free-throw line to make a layup during foul shots. All had been favorite plays of Chamberlain.

## Departure from KU

Chamberlain decided to forego his senior season at Kansas, opting to turn pro. He told the *Lawrence Journal-World* on May 23, 1958: "If I had to start over again from high school, I would want to attend the University of Kansas. I am sorry I have let some of these fine people down, but I have to do this for me. It's what I feel is best."

Having lost the enjoyment from college basketball and wanting to earn money, he left college and sold the story titled "Why I Am Leaving College" to *Look* magazine for $10,000, a large sum when NBA stars earned $9,000 in a whole season. By the time Chamberlain was twenty-one, he had already been featured in *Time, Life, Look* and *Newsweek* magazines, even before he turned professional.

## Professional Career

Chamberlain signed with the Harlem Globetrotters because of the NBA rule that prevented college players from playing in the league until their class graduated. Coach Harp was working in his yard when the Dipper drove up, car already packed. He told Harp that he had accepted Abe Saperstein's offer and thanked him.

He then spent the year traveling the world with a one-year contract that paid him a reported $65,000, an astronomical sum at the time. He traveled all over the world, drawing attention from foreigners who had

never seen a man so tall and impressing them by lifting the backs of cars to show his strength.

The Globetrotters team made history in 1959 by playing in Moscow and enjoyed a sold-out tour of the USSR. One particular Trotter skit involved captain Meadowlark Lemon collapsing to the ground, and instead of helping him up, Chamberlain threw him several feet high up in the air and caught him like a doll. "Chamberlain was the strongest athlete who ever lived," the 210-pound Lemon recounted later. Coach Abe Saperstein placed Wilt as a guard, allowing Wilt to work on skills he never used much as a center. Also, it did increase the comedy of the event, seeing a seven-foot-two man playing the guard position.

## *Harlem Globetrotters*

Chamberlain learned about the pursuit of women from the masters—the Globetrotters. When they weren't trying to get laughs, the Trotters were trying to get laid. The Dipper learned their tricks and fell in step with them, happily and devotedly. If he spotted a pretty woman in the crowd, he'd write his name, hotel and room number on a slip of paper, hide it in his jockstrap and connive a reason to approach the pretty woman, whereupon he would secretly hand her the note—"dropping the bomb," they called it.

He later claimed that his year with the Globetrotters was his most enjoyable season of basketball, and in later years, Chamberlain frequently joined the Trotters in the off-season and fondly recalled his time there because he was no longer jeered at or asked to break records but just one of several artists who loved to entertain the crowd. On March 9, 2000, Chamberlain's number, thirteen, was retired by the Trotters.

## *Philadelphia/San Francisco Warriors (1959–65)*

After the year with the Globetrotters, Chamberlain joined the Philadelphia Warriors, immediately becoming the NBA's best-paid player, earning $30,000 in his rookie contract. In comparison, the previous top NBA earner was the Boston Celtic's Bob Cousy, who earned $25,000.

He made an immediate impact, scoring almost at will. Opposing teams gave up trying to stop him and instead tried only to contain him. Tom Heinsohn, the great Celtics forward, told the *Philadelphia Daily News* in 1991,

"We went for his weakness and tried to send him to the foul line, and in doing that he took the most brutal pounding of any player ever. Half the fouls against him were hard fouls."

With Chamberlain, the Warriors vaulted from last to second in their division and faced the Boston Celtics in the 1960 Playoffs, the first postseason confrontation between Wilt and Bill Russell, a matchup that would grow into the greatest individual rivalry in the NBA. The Celtics won the series 4-2.

Wilt's scoring average during his rookie season was 37.9 points per game, more than 8 points higher than anyone else had ever scored in the history of the NBA, and twenty-seven rebounds per game, also breaking the previous regular-season record. He was named Rookie of the Year and Most Valuable Player, the first person to receive both awards in the same season.

In the 1961 season, Chamberlain surpassed his rookie season statistics and became the first player to break the three-thousand-point barrier and the first and still only player to break the two-thousand-rebound barrier for a single season.

The next season, Chamberlain made a quantum leap in his performance, posting a phenomenal average of 50.4 points per game, and became the only player in NBA history to score more than 4,000 points in a season. He also grabbed 2,052 rebounds, for an average of 25.7 per game. Astoundingly, he played all but eight minutes during the season. On March 2, 1962, he became the first player to score 100 points in a single NBA game, in the Warriors' victory over the New York Knicks. His extraordinary feats in the 1961–62 season were later the subject of the book *Wilt, 1962* by Gary M. Pomerantz (2005).

In the 1962 Playoffs, the Warriors again met the Celtics in the Eastern Division Finals, a team with Bob Cousy and Bill Russell that many consider to be the greatest Celtics team of all time. After splitting the first six games, Chamberlain tied the score at 107 with sixteen seconds to go, but Sam Jones sank a clutch shot to win the championship again for the Celtics.

For the 1962–63 season, Chamberlain continued his array of statistical feats, scoring 44.8 and grabbing 24.3 rebounds per game that year, but the depleted team missed the playoffs. In 1964, the Warriors added rookie center Nate Thurmond. Chamberlain had another good season, with 36.9 points and 22.3 rebounds per game, and the Warriors went all the way to the NBA Finals, succumbing again to the Boston Celtics, 1-4.

## Philadelphia 76ers (1965–68)

The Warriors ran into financial trouble in 1965 and, at the All-Star break, traded Chamberlain to the Philadelphia 76ers. After the trade, he found himself on a promising Sixers team. Statistically, he was again outstanding, posting 34.7 points and 22.9 rebounds per game for the last half of the season. After defeating the Cincinnati Royals, which featured Oscar Robertson, the Sixers met Chamberlain's familiar rival, the Celtics. And again, the teams split the first six games. In game seven, both Chamberlain and Russell were marvelous: Wilt with 30 points and 32 rebounds, and Russell with 16 points, 27 rebounds and 8 assists. With five seconds to go, and Boston leading 110–109, John Havlicek stole the inbound pass to preserve the Celtics' lead. For the fifth time in seven years, Russell's team had deprived Chamberlain of the title.

In the 1966 season, Wilt again dominated the opposition by scoring 33.5 points and 24.6 rebounds a game, obtaining his second MVP award. In the Playoffs, the Sixers again met the Celtics. In game five, Chamberlain was superb, scoring 46 points and 34 rebounds, but the Celtics won the game 120–112 and took the series. Loaded with several other players who could score in 1966–67, Sixers coach Alex Hannum asked Chamberlain to pass the ball more often than shoot and to play more aggressive defense. The strategy worked. Although he failed to win the NBA scoring title for the first time in his career, averaging 24.1 points, Chamberlain recorded the league's highest shooting percentage (.683), had the most rebounds (24.2 average per game) and was third in assists (7.8 average per game). In the Playoffs, the Sixers finally knocked off the Celtics, ending Boston's title streak at eight, before going on to capture the NBA title by defeating the Warriors in six games. Chamberlain said: "It is wonderful to be a part of the greatest team in basketball…being a champion is like having a big round glow inside of you."

Chamberlain himself described that team as the best in NBA history. And in 1980, that 1967 Philadelphia squad was voted the NBA's best team during the first thirty-five years of the league. In 2002, writer Wayne Lynch wrote a book about this remarkable Sixers season, *Season of the 76ers*, centering on Chamberlain.

In the 1968 season, Wilt led the league in assists (the only center in NBA history to finish the season as the league's leader), rebounding and field goal percentage and finished third in scoring. He won his fourth and last MVP title and became the NBA's first player to ever score twenty-five thousand career points. But after the Sixers blew a 3-1 lead in the Eastern Division finals to Boston, Chamberlain was traded that summer to the Los Angeles

Lakers, where he was teamed with future Hall-of-Famers Elgin Baylor and Jerry West, creating one of the most prolific scoring machines of all time.

## *Los Angeles Lakers (1969–73)*

Lakers owner Jack Kent Cooke gave Chamberlain an unprecedented contract, paying him $250,000. In comparison, previous Laker top earner Jerry West was paid $100,000. When he became a Laker, Chamberlain built a million-dollar Bel-Air mansion he called Ursa Major (the stars of the Big Dipper appear in that constellation). It was described as a miniature playboy mansion, where he regularly held parties and lived out his notorious sex life. In addition, Chamberlain drove a Ferrari and a Bentley and engaged James Bond car designer Peter Bohanna to design the Chamberlain Searcher I, a $400,000 custom sports car.

In the 1969 Playoffs, the Lakers were matched up again to Boston in the finals. The Lakers were heavily favored to win against the old, battered Celtics. In game seven, Lakers owner Cooke had put up thousands of balloons in the rafters of the Forum. This display of arrogance motivated the Celtics to win 108–106.

In his second year with the Lakers, Chamberlain experienced a problematic and often frustrating season. Baylor and Chamberlain played only a handful of games together as teammates due to injuries. Chamberlain's injury also severely limited the number of games he played. But he came back at the end of the season, and the Lakers charged through the Playoffs and faced the New York Knicks in the title game. The hero of game seven was Willis Reed, as he famously limped onto the court, scoring the first four points, and inspired his team to one of the most famous Playoff upsets of all time.

After winning the Pacific Division title in 1971, the Lakers lost Elgin Baylor to an Achilles tendon rupture that ended his career and lost Jerry West to a knee injury, so they were decided underdogs against the Milwaukee Bucks, who were led by Lew Alcindor (later Kareem Abdul-Jabbar) and veteran Hall-of-Famer Oscar Robertson. Although they lost, Chamberlain was lauded for holding his own against MVP Alcindor, who was not only ten years younger but also had two healthy knees.

Chamberlain averaged only 14.8 points in 1971–72, a season that proved to be one of the most rewarding in his career. That season, the Lakers went on a record thirty-three-game winning streak on the way to a then-record 69-13. Chamberlain jokingly claimed to be unimpressed: "I played with the Harlem Globetrotters and we won 445 in a row and they were all on the road." The

Lakers then stormed to their first NBA championship with a five-game triumph against New York in the 1972 NBA Finals, and Chamberlain was voted the Finals MVP.

The next season was Chamberlain's last. For the season he averaged 13.2 points and 18.6 rebounds, still enough to win the rebounding crown for the eleventh time in his career. In addition, he shot an all-time NBA record 72.7 percent accuracy from the field, his ninth time. The Lakers won sixty games and reached the Finals against the Knicks. With Jerry West injuring his hamstring again, the Lakers were no match for a healthy team of Knicks, who won the series 4-1.

Chamberlain left the NBA as the all-time leader in points scored (31,419) and rebounds (over 23,924) and with four Most Valuable Player awards and more than forty league records.

So who was the greatest professional player ever? In comparison to other big men, Wilt scored more points per game in his career (29.1) than Kareem Abdul-Jabbar (24.6) or Shaquille O'Neal (24.7) and grabbed more career rebounds per game (23.1) than Bill Russell (22.8) or O'Neal (11.4). Against Michael Jordan, arguably his only competitor for the title of "greatest," he scored slightly less than Jordan's 30.6 points per game but grabbed 16.8 more rebounds per game. Also, no one has come even close to his regular season average in 1962 of 50.4 points per game, a year in which he scored 100 points in one game. I'll take Wilt over all of them.

## Post-NBA Life

Wilt engaged in successful business and entertainment ventures, made money in stocks and real estate and appeared in numerous ads, including a memorable Volkswagen commercial that played on the length of his legs in relation to the size of the car. Volleyball became his new sports passion, and he became a board member of the newly founded International Volleyball Association in 1974 and its president one year later. He played occasional matches for the Seattle Smashers before the league folded in 1979. He promoted the sport so effectively that he was named to the Volleyball Hall of Fame. He also played tennis and racquetball, ran the Honolulu marathon and even played polo. In 1984, he appeared in the movie *Conan the Destroyer*.

In 1973, Wilt published the first of two autobiographies, *Wilt: Just Like Any Other Seven-Foot Black Millionaire Who Lives Next Door*. Nearly two decades later, a second autobiography, *A View From Above*, caused a much bigger stir with his notorious claim to have had sex with twenty thousand women. As his lawyer Sy

Goldberg put it: "Some people collect stamps, Wilt collected women. I think Wilt hit on everything that moved…but he never was bad or rude." Wilt later said that claim was an offhand remark that the publisher exploited. In a 1999 interview shortly before his death, Chamberlain regretted not explaining the sexual climate at the time of his escapades and warned other men who admired him for it, closing with the words: "Having a thousand different ladies is pretty cool, I have learned in my life. However, I've found out that having one woman a thousand different times is much more satisfying."

In his great cathedral house in Los Angeles he did not keep a single trophy attesting to his individual achievements, except for his Naismith Memorial Hall of Fame certificate. He gave all the others away. "They make other people happier," he said.

## *Return to KU*

I had the great opportunity to be present in Allen Field House when Wilt finally came back to Lawrence, his first visit since leaving KU after his junior year. The following is an excerpt written by the *Lawrence Journal-World*'s Bill Mayer, who described the evening thus:

> *In about a 10-minute period here in 1998, Wilt Chamberlain shifted from a moment of fearful apprehension to what he emotionally described as "the greatest moment of my life." The scenario included the hanging of his No. 13 Kansas University basketball jersey in Allen Field House and his receiving a thunderous ovation from fans he had feared might be hostile and derisive.*
>
> *"What's likely to happen out there?" Wilt asked. "Will they be cool, angry, happy…what?" "Uncle Dippy," I responded, using a nephew's pet nickname and my favorite, "you're going to get the greatest reception you've ever had. You don't realize how people around here have come to admire you, no matter what you might have thought."*
>
> *"I hope you're right," he said with that trademark skepticism, developed over decades to avoid exploitation. Off we went to the northwest tunnel where the Jayhawks enter and leave. Chamberlain no sooner came into view of the crowd than the "WILT! WILT! WILT!" chant began to build. He still said he was "scared as hell." The cascades of perspiration continued.*
>
> *"You're in for a wonderful surprise," I said as he headed to center court for an intro by Max Falkenstien, who'd also worked with The Dipper as an announcer, and on his radio show, Flip'er with Dipper.*

*The dam of adulation broke, big-time, and it was all Max could do to get things in order for the presentation. It was a tremendous event, for everyone, with Wilt undergoing a catharsis of his fears and the crowd letting him feel its admiration.*

*Wearing his Jayhawk letter jacket and perspiring heavily from the heat and worry, he told the adoring '98 crowd, in part, "A little over 40 years ago, I lost my toughest battle in sports in losing to the North Carolina Tar Heels…It was a devastating thing to me because I thought I let the University of Kansas down and my teammates down. But when I come back here today and realize not the simple loss of a game, but how many people have shown such appreciation and warmth (horrendous crowd roar, tears in a choked-up Wilt's eyes), I'm humbled and deeply honored…I'm a Jayhawk and I know now why there is so much tradition here and why so many wonderful things have come from here, and I am now very much a part of it by being there (on the Field House south wall) and very proud of it…Rock Chalk, Jayhawk!"*

*As he returned to the tunnel to go back to his seat, Wilt commented: "This is the greatest moment of my life. I NEVER had any idea it would or could be like this. Nothing this wonderful has ever happened to me before, and won't ever again. What a fantastic thing Kansas has here."*

## The End

Chamberlain had a history of heart trouble. In 1992, he was hospitalized for three days following an irregular heartbeat, and in 1999, his condition deteriorated rapidly. After undergoing dental surgery in that year, he lost fifty pounds, was in great pain and seemed unable to recover from the stress. On October 12, 1999, Chamberlain died. Four days after Chamberlain's death, a strong earthquake shook Southern California, causing people to joke that Wilt must have arrived at the Big Dipper.

Four years after his death, Wilt's estate announced a gift of $650,000 to Kansas University. The largest portion of the gift, $300,000, establishes a fund for KU men's basketball, the interest paying for one scholarship per year. Another $100,000 pays for a scholarship to be given to a senior women's volleyball or basketball player, alternating each year. Chamberlain's donation also included $150,000 to finance the annual basketball clinic at KU for the Special Olympics. The remaining $100,000 will be a need-based scholarship.

# THE FOUNDATION

## 1898–1921

From the very beginning, basketball has been something special at the University of Kansas.

When Dr. Naismith arrived at KU, he brought the game of basketball to his physical education class. Bored with the monotonous routine of calisthenics, the students welcomed a competitive sport, and eight teams were quickly organized. A series of tournaments was arranged to select players for the first varsity team. In 1898–99, home games were played on a skating rink, and the season ended with a winning record of 7-4. However, fire destroyed the old building, and the Jayhawks were left without a basketball home. So in 1900, KU rented the Lawrence YMCA for its home games and practice sessions. For the remainder of Naismith's tenure as coach, the team played in Snow Hall, which had large pillars in the middle of the court, hindering the players' attempts to run up and down the court.

The next six seasons were not as successful, as KU experienced a losing record each year. However, a man destined to be a dominant figure in the basketball world entered the University of Kansas as a student in 1905. He was Forrest C. "Phog" Allen, who had learned the game as a member of the athletic club team in his hometown of Independence, Missouri. Dr. Naismith met young Allen early in the 1900s, when he took his team to Independence to play the athletic club. In 1905, Allen was a member of the Kansas City Athletic Club's famous team that defeated the touring Buffalo (New York) Germans, claimants of the national basketball championship.

With Phog on board, the Jayhawks' 1906 season ended with a 12-7 record, and he was KU's first basketball star. Allen resigned as captain of the 1906–07 team and left KU to become head basketball coach at Baker University in Baldwin City, Kansas. However, Allen returned the next year to succeed Naismith as KU's coach for the 1908 and 1909 seasons.

W.O. Hamilton's ten years as coach at Kansas bridged the gap between Phog Allen's two tenures as KU's coach. Hamilton met with instant success, completing the 1910 season with an 18-1 record, led by Tommy Johnson, KU's first All-American. During his ten years as the Jayhawk head coach, Hamilton amassed a 125-59 record with five conference titles.

Coach Hamilton resigned to devote more time to his budding Chevrolet dealership after the 1918 season, so the Jayhawks assigned track coach Karl Schlademan to take over the basketball program. At the same time, Phog Allen had been named athletic director. After less than four months on the job, Phog was faced with his first major crisis, since Schlademan resigned after one game to devote his energies to the track team. There was no time to launch a search, so Phog appointed himself as varsity coach. The 1920 team finished 11-7 overall, third in the Missouri Valley Conference.

## FORREST CLARE "PHOG" ALLEN
## (PLAYER: 1905–07; COACH: 1908–09, 1920–56)

*The game and the sport that it brings is the thing that makes it all worthwhile, not the winning.*
*—Phog Allen*

Dr. Phog Allen is widely recognized as the "Father of Basketball Coaching," and his legacy is forever etched into Kansas's basketball history.

His nickname was originally "Foghorn," stemming from his days when he umpired baseball games and bellowed his decisions. A sportswriter named Ward (Pinhead) Coble shortened and fancified it to Phog. Actually, his players and most people around the KU campus called him "Doc," although his grandchildren called him Phoggy.

## Early Years

Phog was born on November 18, 1885, in Jamesport, Missouri, the fourth of six boys in the Allen family. When he was two years old, the family moved to Independence, where he grew up and lived on the same street as future president Harry S Truman. It was there that he learned and exhibited the athletic and organizational skills that garnered him so much success in later years.

When basketball was only ten years old, he and his brothers formed the Allen Brothers Basketball team and played all comers. The early rules of basketball specified that one member of the team should toss all the free throws. Phog performed that duty for the Allen boys, and he was very good at it.

In 1903, Allen joined the Kansas City Athletic Club, nicknamed the "Blue Diamonds," and became their star forward, free thrower and manager. Phog came up with a plan to invite the Buffalo Germans, named by the AAU as the mythical national champion in 1904, to play the Blue Diamonds, a game he billed as the "World's Championship of Basketball." He rented the enormous Convention Hall for the match, which was to be the best of three games. The Germans won the first game, refereed by a Buffalo substitute. The second game was won by the KCAC, which was refereed by a Kansas City local. The Germans' suggestion of James Naismith as the referee for the third game was accepted by the KCAC, and Phog sank seventeen free throws to lead the KCAC to a 45–14 victory in front of four thousand fans.

## Going to College

Phog began as a student at the University of Kansas, where he quickly lived up to his reputation. On February 12, 1906, he played in his first full game, a 37–17 triumph over Nebraska. The *Kansan* reported, "Fog Allen did star work at forward, making 23 out of the 37 points." He also played baseball, lettering two years.

During his college tenure, he married Bessie E. Milton and started a family that eventually consisted of six children, two of whom played for him at Kansas.

He succeeded Naismith as KU's second coach in his senior year in 1907–08 at KU, where he led the Jayhawks to an 18-4 record. The next year, he also coached at two nearby schools, Baker University and Haskell Indian Institute. Kansas was 25-3 that season, Baker 22-2 and Haskell 27-5, for a combined record of 74 wins and 10 losses.

When Allen was first thinking about making a career of coaching, he talked with Naismith and was told, "You don't coach basketball, Forrest; you play it."

"Well," Allen replied, "you can coach them to pass at angles and run in curves." Despite the bit of advice, Allen went ahead with his career and disproved Naismith.

## Becoming a Physician

After coaching KU for two years, Allen took a hiatus for three years to study osteopathic medicine at the Central College of Osteopathy in Kansas City, gaining the skill for which he later became famous in the treatment of athletic injuries.

He returned to coaching in 1912 to coach all sports at Warrensburg Teachers College (now Central Missouri State), from 1912–13 through the 1919 season. His basketball teams won championships all seven seasons, with an astounding record of 102-7.

## Back to Mount Oread

Allen left Warrensburg to become Kansas's athletic director in the fall of 1919, as well as football coach. He coached football for only a single season, where he had a record of 5-2. After the first basketball game of the season, KU coach Karl Schlademan left the job to concentrate on his duties as track coach, so Phog took over the team. "I was just a dumb cluck," Allen joked to the *Kansas City Star*. "I wasn't supposed to be a basketball coach in the first place. I took it because the guy who was supposed to be the coach was too scared of these boys coming back from the war."

After a couple of mediocre seasons in 1920 and '21, the team gelled, and the Helms Foundation named his 1922 and 1923 squads national champions. Also in 1923, Dr. Allen and Dr. John Outland (for whom the Outland Trophy was later named) headed the creation of the Kansas Relays.

His 1924 book, *My Basket-Ball Bible*, sold fourteen thousand copies and helped set a course for college basketball. During the next four seasons, his teams compiled a 64-8 record and won four league championships.

When the dribble was abolished in basketball in 1927, Allen became so angry that he quickly formed a meeting of coaches in Des Moines, Iowa, after the Drake Relays. He spread so much dissension toward the new

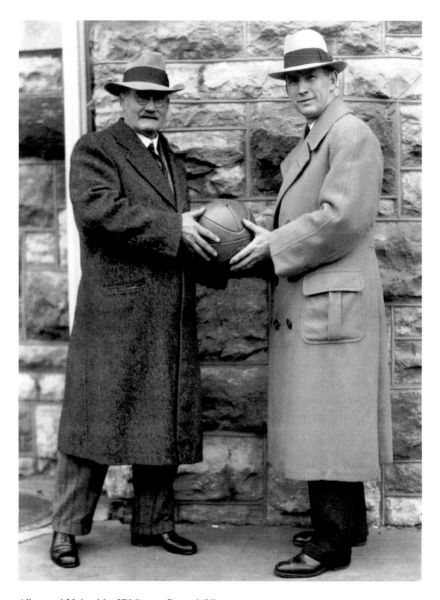

Allen and Naismith. *KU Spencer Research Library.*

rule that it was overturned, and the dribble was back in the games. From that protest, the National Association of Basketball Coaches (NABC) was formed, and Allen served as its first president.

That same year, he led the effort to construct a new football stadium. He made the following comment published in the *Kansas City Star*:

*Of course it is fine to win in basketball as it is in all other sports, but I hold my minor part in putting over the stadium prospectus, the location, the building of the first unit, the convincing of the committee that we could pay our bonding indebtedness on the $80,000 dressing rooms, our record payment in two years, and now the decision to complete the stadium as the most delightful and gratifying thing that has come to me in athletics.*

In the fourteen seasons from 1930 through 1943, the Jayhawks captured the conference crown eleven times, during which they became the NCAA national runner-up in 1940. While Phog's technical competence was extraordinary, his greatest asset was his ability to motivate players and establish a winning attitude. "Somehow he convinced you that when you played for Kansas you were supposed to win," recalled Ted O'Leary, former player and later journalist at *Sports Illustrated*. "He was a very enthusiastic, positive man, and he made you share his enthusiasm." Ray Evans said, "He could get you fired up to the point you wanted to knock the door down."

Above his office desk hung a portrait of the late Dr. Naismith, inscribed in 1936: "With kindest regards to Dr. Forrest C. Allen, the father of basketball coaching, from the father of the game."

Allen coached two of his sons, Mitt, who won letters in 1934–36 and went on to law school, and Bob, who lettered in 1939–41, graduated Phi Beta Kappa and went on to medical school. Phog also became, in time, the progenitor of a long line of prominent coaches, including Hall-of-Famers Adolph Rupp at Kentucky, Dutch Lonborg at Northwestern, Dean Smith at North Carolina, Frosty Cox at Colorado and Ralph Miller at Wichita State, Iowa and Oregon State.

As early as April 1928, just before the Amsterdam Olympics, Allen proposed that basketball be considered as an "international demonstration sport" but was turned down.

Over the objections of AAU officials, with whom he had various feuds over the years, Phog continued pushing hard for the idea. He and others were persistent and finally got their message across. So, in October 1934, the Olympic organizing committee adopted a resolution to have basketball included in the XI Olympiad in Berlin in 1936.

Once he had accomplished that, Phog wanted to find a way to send the game's inventor, Dr. James Naismith, over to Germany to see the Olympic debut of the game he invented. Allen conceived a plan that had each high school and college withhold one cent from the price of each admission to one game played during the week of February 9–15 to finance the trip to

Germany for Naismith and his wife. Those funds, together with a sizeable contribution from the National Association of Basketball Coaches, made it possible for Dr. Naismith to go to Berlin, although Maude, his wife, couldn't go because of illness.

Phog was also instrumental in the creation of the NCAA tournament established in 1939. In January 1943, the Helms Foundation named Allen as the "greatest basketball coach of all time," based on its survey of coaches and basketball authorities across the country.

He was a colorful figure on the University of Kansas campus and became widely known for his osteopathic manipulation techniques for ailing athletes. Dr. Allen was a legend in the field of treatment of athletic injuries and included a long list of high-profile performers, especially baseball players such as Mickey Mantle, Grover Cleveland Alexander and Johnny Mize.

Although there were some relatively down years after World War II, Allen did an excellent job of recruiting in the late 1940s, building a team led by All-American Clyde Lovellette that culminated in winning the NCAA championship in 1952. After the title game, which the Jayhawks won over St. John's, 80–63, Phog wrote a letter to his players, saying:

> *It's been great fun. But twenty-five or thirty years from now you boys will radiate and multiply the recollections of your struggles and your successes and your defeats and your dejections. All these will be rolled into a fine philosophy of life which will give you durable satisfactions down through the years.*

Allen long campaigned loudly to increase the height of the basket to twelve feet. "The tall men are killing the passing, the dribbling, the teamwork that makes basketball exciting."

"If we raised the goals," he said in 1940, "these mezzanine-peeping goons wouldn't be able to score like little children pushing pennies into gum machines. They would have to throw the ball like anyone else. They would have to make the team on real skill, not merely on height." However, after recruiting Wilt Chamberlain, he said with a quiet smile: "Twelve-foot baskets? What are you talking about? I've developed amnesia."

Allen Field House, opened in March 1, 1955, was named for him and is still the home court for KU basketball. A mandatory retirement age of seventy forced him from the bench against his wishes after the 1956 season. He said with some bitterness that he had reached the state of "statutory senility." Nonetheless, he then established a successful private osteopathic

practice, and many he treated contended he had a "magic touch" for such ailments as bad backs, knees and ankles.

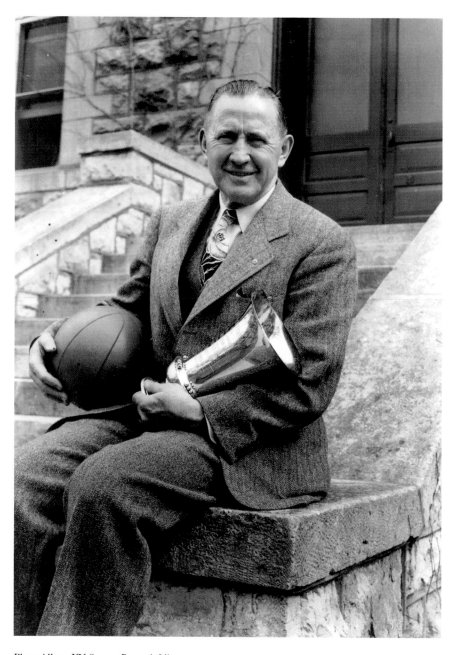

Phog Allen. *KU Spencer Research Library.*

## *The Legacy*

Phog coached college basketball for forty-nine seasons and compiled a 771-223 record, retiring with the all-time best coaching record in collegiate basketball history.

The fruits of his efforts are forever etched into Kansas's basketball history. In thirty-nine seasons at KU, Allen won an amazing 590 games, a winning percentage of 73 percent, including three national championships and twenty-four conference championships.

He was named National Coach of the Year in 1950 and was a charter inductee to the Naismith Memorial Basketball Hall of Fame in 1959. He was also inducted into the University of Kansas Athletic Hall of Fame and the Missouri Sports Hall of Fame.

Phog died on September 16, 1974, at the age of eighty-eight and is buried in Lawrence Oak Hill Cemetery, not far from the grave of Dr. Naismith.

## TOMMY JOHNSON (PLAYER: 1909–11): KU's FIRST ALL-AMERICAN

*There is glory, there is tragedy, in the story of Tommy Johnson, whose name has rightly gone down in University annals as K.U.'s greatest athlete. Many a victorious Jayhawker received the inspiration necessary to come from behind against overwhelming odds from the "Man Who Died for Kansas."*
*—1931 Jayhawker yearbook*

Once called the "greatest athlete ever to wear the colors of Kansas University" by the *Lawrence Journal-World*, Johnson was KU's starting quarterback on the football team, ran high hurdles and pole vaulted for the track team. He also starred on the basketball court, earning a total of eleven letters.

He began his career on the basketball court in 1905, when he led KU to its second winning season and a 12-7 record. Johnson left school and returned again in 1907, when he helped lead the Jayhawks to their best record in school history to that point. In 1909, after leading Kansas to a 25-3 record and its second Missouri Valley Conference basketball title, Johnson was named an All-American, KU's first in any sport.

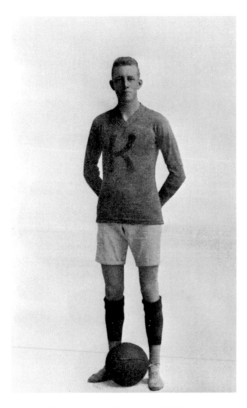

Tommy Johnson in a K sweater. *KU Spencer Research Library.*

As starting quarterback for three years, the five-foot-eleven, 160-pound Johnson led the Jayhawks to an impressive record of 23-2-1. The football team was undefeated in 1909 and would have likely been undefeated in 1910 had not Johnson incurred a concussion during the final game of the season against Missouri and been unable to perform at top capacity.

That winter, after having recovered from the severe concussion he received during the game, Johnson led the 1910 basketball team to another conference championship and an overall record of 18-1. After breezing to an 8-0 record, KU hosted Missouri, heating up a rivalry between the Jayhawks and the Tigers that has lasted to 2012. Early in the half, Johnson was tackled by Missouri's Theodore Hackney. Attending the game, described as a cross between a basketball game and a wrestling match with a generous sprinkling of football thrown in, Dr. Naismith cried, "Oh my gracious! They are murdering my game!" When that season ended, Johnson helped lead student opposition to an attempt by certain members of the Board of Regents to abolish football at KU and replace it with the more "civilized" game of rugby.

Both Johnson and football returned to KU for the fall semester of 1910. KU entered the finale against Missouri with a 6-1 record. In a game that ended in a 5–5 tie, Johnson reaggravated a kidney condition that had plagued him as a youth. Over the next year, his health steadily deteriorated. As the team prepared for the 1911 season, Johnson became quite ill with tuberculosis. On November 24, 1911, the most accomplished athlete KU had known to that time died of kidney failure at the age of twenty-four.

Johnson's death was a blow. The *Kansan* reprinted a poem written by a W.N. Randolph that had run in the *Kansas City Star*:

*Now let the waving pennons droop*
*And hush the battle trumpets' roar*
*As friend and foe the head bow low,*
*For Tommy Johnson is no more.*

In 1935, the University of Kansas honored Johnson at halftime of the homecoming game against Missouri. In front of a sold-out crowd at Memorial Stadium, with flags flying at half mast, former teammates celebrated him as the best athlete in KU history.

Mark D. Hersey, a professor of history at KU, once noted that the "man who earned the first nationally recognized individual athletic award in the University's history and whom institutional historians have dubbed 'the Original KU Legend' has not yet had his football or basketball jersey retired by the school at which he distinguished himself." Unfortunately, this need is yet unfilled.

## JOHN WILLIAM "BUNNY" BUNN
## (PLAYER: 1918–20; ASSISTANT COACH: 1921–30)

*As a coach, teacher, lecturer and prolific writer, John Bunn was a national and international authority on basketball.*

### Ten-Letter Athlete

John Bunn was born in Wellston, Ohio, on September 26, 1898. Playing football, basketball and baseball, he won ten letters at the University of Kansas. He came to KU from Humboldt (Kansas) High School, where he was a twelve-letter man and class valedictorian. He played basketball for coach W.O. Hamilton for two seasons and for Phog Allen during his senior year.

## *Coaching Career*

Upon completing his bachelor's degree, Bunn became Allen's assistant coach for nine seasons, serving as freshman coach of the football, basketball and baseball programs. Additionally, he was an assistant athletic director for four years and was a professor of industrial engineering. In 1930, he became men's basketball head coach at Stanford University, building the Cardinal program into a national power. Bunn's teams played a coast-to-coast schedule, a rarity in those days, which helped bring West Coast basketball to national prominence. In 1937, Stanford won the Helms Foundation National Championship behind Hall-of-Famer Hank Luisetti. Although Bunn emphasized defense, his team was best known for making the one-hand jump shot a powerful offensive weapon. Bunn was one of the few coaches of the era who would have allowed Luisetti to use what was then a very unorthodox way of shooting. Luisetti's style was soon adopted by other players.

Luisetti's last year at Stanford was also Bunn's. Bunn temporarily retired from coaching in 1939 to become a college administrator but soon tired of the administrative life. In 1945, he was named as an athletic consultant for the U.S. War Department. During the next six years, he traveled often to Europe to supervise the establishment of athletic facilities and programs for the military. Due to his extensive foreign travel, Bunn was dubbed the "American Ambassador of Basketball." He returned as coach at Springfield College, basketball's birthplace, from 1947 through 1956. During his tenure at Springfield, Bunn was named the first chairman of the Naismith Memorial Hall of Fame Committee, serving from 1949 to 1969. He finished his coaching career at Colorado State College (now the University of Northern Colorado) from 1956 through 1962. His overall record was 313 wins, 288 losses.

## *After Coaching*

After he retired as a coach, he was a member of the NCAA rules committee, serving as its national rules editor and interpreter for nine seasons (1959–67). In that capacity, he personally initiated several rules changes. He served as the chair of the National Basketball Association's Hall of Fame Committee from 1949 to 1961. He also wrote six influential books on coaching, officiating and team play. His most famous book, *The Scientific Principles of*

*Coaching*, published in 1955, was a pioneering work applying the principles of mechanical engineering to athletic performance and was translated into several foreign languages.

## Legacy

On October 1, 1964, Bunn was inducted into the Naismith Memorial Basketball Hall of Fame as a contributor. At the time, he lived in Glenwood Springs, Colorado.

The John Bunn Lifetime Achievement Award was instituted by the Basketball Hall of Fame's Board of Trustees in 1973 to annually honor an international or national figure who has contributed greatly to the game of basketball. Outside of enshrinement, the John Bunn Award is the most prestigious award presented by the Hall of Fame.

## ARTHUR C. "DUTCH" LONBORG (PLAYER: 1918–20); ATHLETIC DIRECTOR: 1950–64)

Dutch Lonborg's parents immigrated to the United States from Denmark when his mother was eighteen and his father twenty-one. Born in Gardner, Illinois, in 1898 and raised in Horton, Kansas, Arthur C. "Dutch" Lonborg was a multisport letterman at Kansas University, earning nine letters, three each in football, basketball and baseball. He was a three-time all-conference performer as a quarterback in football (1917–19) and was twice named all-conference in basketball, including being named All-American in 1919.

As a child, he spoke Danish at home, and when he got to grade school, he once explained, "I sounded so Dutchy that I acquired a nickname which has lasted a lifetime."

After leaving KU, Lonborg then played for the Kansas City Athletic Club Blue Diamonds, which won the National AAU Championship in 1921. He then returned to Kansas to attend law school. After graduating from law school, Lonborg had a successful two-year stint in coaching at McPherson College, followed by four years at Washburn University, where his 1925 team won the national AAU title. He then began a twenty-three-year career as basketball coach at Northwestern University. He compiled 237 wins to rank him first on the school's all-time victory list, leading the Wildcats to

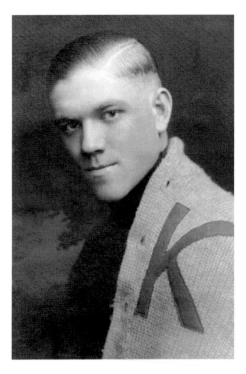

Dutch Lonborg. *KU Spencer Research Library.*

Big Ten titles in 1931 and 1933. His 1931 team was recognized by the Helms Foundation as the national champion.

While at Northwestern, he was named president of the National Association of Basketball Coaches in 1935–36 and was instrumental in organizing the first NCAA basketball tournament in 1939. The first championship game, in which Oregon defeated Ohio State, was played in Northwestern's Patten Gymnasium. In 1941, Dutch organized and coached a team of college all-stars against an NBA team, an event that lasted over nine years. In 1947, he became chairman of the NCAA Division I Men's Basketball Committee, serving until 1960.

He returned to his alma mater in 1950 as KU's athletic director, a position he held for fourteen years. During his tenure, the Jayhawks won thirty-eight conference titles in all sports and took four NCAA crowns in various sports, including the 1952 basketball title. In addition, Allen Field House, Quigley Field (now Hoaglund-Maupin Stadium) and Memorial Stadium expansion projects were completed.

Lonborg served as chairman of the U.S. Olympic basketball committee from 1956 to 1960 and as the manager of the 1960 Olympic basketball team. He also spent thirteen years as the chairman of the NCAA basketball tournament committee and as chair of the 1959 U.S. Pan American Games.

A member of the KU Athletics Hall of Fame and the Helms Foundation Hall of Fame, he was elected to the Naismith Basketball Hall of Fame in 1972 and passed away in Lawrence on January 31, 1985.

# THE GOLDEN YEARS

## 1922–1927

After a ten-year hiatus, Phog Allen came back to KU as the athletic director in 1919. Shortly after starting the job, W.O. Hamilton, his successor as basketball coach in 1909, resigned and was replaced by track coach Karl Schlademan. Schlademan, however, resigned after one game to devote his time to the track team. So Phog, who had been coaching the freshman team, appointed himself as the varsity coach. His first two years, 1920 and 1921, resulted in "rebuilding" records of 11-7 and 10-8. The 1922 team, however, was loaded with junior Paul Endacott and sophomore Charlie Black. Compiling a 17-1 overall record, it won the Missouri Valley championship and was named national champion by the Helms Foundation.

Endacott and Black returned for the 1923 season and were joined by sophomore Tus Ackerman, forming one of KU's best all-time teams, which again won the conference and was named national champion. Endacott was named Player of the Year by the Helms Foundation. Phog Allen once said, "For its size and talent, the 1923 team did more than any other team I ever had."

With Endacott gone in 1924, Black and Ackerman led the team to a 16-3 record in 1924 and another league crown. In 1925, All-American Ackerman led the Jayhawks to a 17-1 record and another league title. Although the stars were gone in 1926, the Jays went 16-2 and took first again in the conference; in 1927, they also won the conference and finished 15-2.

During this six-year period, the Jayhawks won 90 percent of their games (98-11 overall) and six straight league titles (with a record of 87-7)

and were named national champion twice. Allen had restored Kansas to national prominence.

## PAUL ENDACOTT (PLAYER: 1921–23)

Named to the Naismith Basketball Hall of Fame in April 1972, legendary coach Phog Allen often called Endacott the "greatest player I have ever coached" and was fond of telling about Endacott's heroics during KU's game at Missouri on January 16, 1923, which the Jayhawks won 21–19. Endacott grabbed sixteen straight jump balls in the closing minutes to preserve the win and later collapsed in the locker room from exhaustion.

Endacott was born on July 3, 1902, and after learning basketball from Dr. James Naismith at the Lawrence YMCA, he graduated from Lawrence High

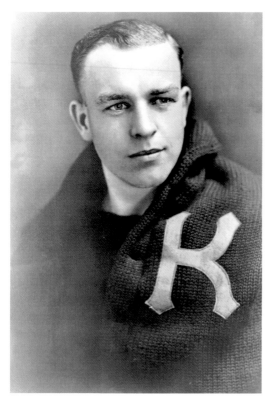

School in 1919 and attended Kansas as a walk-on to play for coach Allen. He earned All–Missouri Valley Conference honors in his sophomore year. A five-foot-ten guard, he then led KU to two national championships in 1922 and 1923 and was named All-MVC and All-American both years, along with being named Helms Athletic Foundation Player of the Year in 1923. He was KU's first Honor man, an annual award given to the student displaying leadership, scholastic achievement and greatest overall contribution to the student body and university.

After graduating with a degree in civil engineering, Endacott went to work for

Paul Endacott in a KU sweater. *KU Spencer Research Library.*

the Phillips Petroleum Company and played on its company AAU team for five seasons. He worked in the oilfields as an engineer and caught top management's eye by persuading Chrysler Corporation to be the first to convert a big plant's heating system to butane. He rapidly climbed the corporate ladder, rising to head of sales research in 1934, vice-president in 1943 and eventually becoming the company's president before retiring in 1967.

While president of Phillips, his staff ironed out kinks in its innovative plastic production process, and his sales force lined up new markets for the plastics, one of which was Wham-O, which sold more than 100 million Hula Hoops in the first six months on the market. Delighted, Endacott kept a Hula Hoop in his office for impromptu demonstrations of the miracle plastic in action.

Endacott sat on the board of the KU Alumni Association from 1927 to 1940 and served as its chairman from 1939 to 1940. In 1977, he received the Fred Ellsworth Medallion for his service to KU. He championed the idea of a club for retired KU faculty and staff, donating funds to provide meeting space for the club, now known as the Endacott Society.

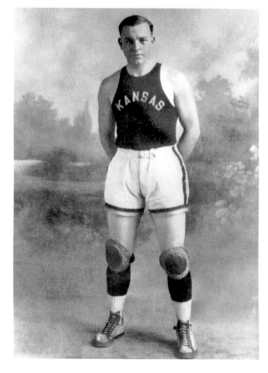

In 1969, he received the Sportsman's World Award in the category of basketball, an honor given to athletes whose championship performances have stood the test of time and whose exemplary conduct have made them outstanding inspirations for the youth of today to emulate. In 1972, he was inducted into the Naismith Basketball Hall of Fame.

Endacott's jersey was retired in a ceremony at halftime of the KU-Nebraska game on January 25, 1992. He died on January 8, 1997, in Bartlesville, Oklahoma, and was posthumously inducted into the Kansas Sports Hall of Fame on October 4, 2009.

Paul Endacott in a KU uniform. *KU Spencer Research Library.*

## ADOLPH FREDERICK RUPP (PLAYER: 1921–23)

Known as the "Baron of Bluegrass," Adolph Rupp coached at Kentucky for forty-two seasons and compiled a record of 875 wins and 190 losses—a winning percentage of 82 percent—retiring in 1972 and passing his mentor, Phog Allen, as the winningest coach in NCAA history.

As a youngster, Rupp worked on his Mennonite family farm and attended a one-room schoolhouse in the country. He was a star on his Halstead, Kansas high school team, averaging over nineteen points per game. After high school, Rupp attended the University of Kansas and was a reserve on the 1921–23 teams. His teammate Paul Endacott said:

> *He told me that he only had $30 in his pocket—the crops on the farm not having been successful that year and he was looking for a job. He found one at the student Jayhawk Café patronized during the late evenings by students who lived nearby. He attracted many customers because he talked constantly while going back and forth behind the counter, sometimes even quoting passages from the Bible. He was like an orator.*

In his three years on the varsity, Rupp didn't see enough time to earn a letter. The starters played most of the minutes, and Rupp was on what Coach Allen called his Meat Packers, who got to play only when the game was clearly secured. But in a letter requesting that the school authorize basketball K's, coach Allen made special attention: "Adolph Rupp has worked three consecutive years, given the best he had in him for the success of the team. That man should receive a recommendation for a letter."

After graduation, Rupp looked for opportunities in banking but soon opted to take a teaching and coaching job at Burr Oak, Kansas, and later coached high school teams in Marshalltown, Iowa, and Freeport, Illinois, before taking over as head coach at Kentucky in 1931. During his time in Freeport, Rupp taught history and economics and earned a master's degree in education and economics while taking courses at Columbia University during the summers. He also traveled to nearby Madison to observe and learn from University of Wisconsin basketball coach Dr. Walter "Doc" Maxwell.

As coach of the University of Kentucky Wildcats, Rupp guided his teams to twenty-seven Southeastern Conference titles, an NIT championship and four NCAA crowns (1948, 1949, 1951 and 1958). A master of motivation and strategy, he promoted a sticky man-to-man defense, a fluid set offense,

perfect individual fundamentals and a relentless fast break that battered opponents into defeat.

Twenty-five players were All-Americans under his guidance, and thirty-one of his players played professionally. He was named National Coach of the Year four times and SEC Coach of the Year seven times. He served as co-coach of the 1948 U.S. Olympic gold medal team in London and was selected as an Olympic goodwill ambassador to the 1968 games in Mexico City. Rupp Arena in Lexington, Kentucky, home of the Kentucky Wildcats, is named in his honor. He was elected to the Naismith Basketball Hall of Fame in 1959.

Adolph was pleasant when he wasn't coaching and was dynamic, controversial and colorful. While he had a great sense of humor and easily developed friends, he certainly wasn't the most liked person in his profession, as he was arrogant, egocentric and often downright rude, relentlessly driven by a dedication to winning, often at the expense of the rules. He also ran his practice sessions like a marine boot camp. All-American Alex Groza said, "From the time you walked into the gym and left, you were there to play basketball."

In 1974, two years after his retirement, Rupp reported in an interview for the *Halstead Independent* during a visit there that he was still very busy. He was vice chairman of the Kentucky Colonels, a professional basketball team; chairman of the board of directors of the Shriner's Children's Hospital; and a farmer with a five-hundred-acre farm where he raised thirty-five thousand pounds of tobacco a year and ran

Adolph Rupp in a KU uniform. *KU Spencer Research Library.*

a herd of registered Herefords. He served as president of the Kentucky Hereford Association.

He died on December 10, 1977. When told of his passing, Larry Steele, one of many of his players who went on to play professional basketball, said, "He was an unbelievable coach. Everyone around the country knew what kind of a coach he was, but if you mention his name in Kentucky, it was impossible to describe the reaction you'd get. He was a true legend."

# CHAPTER 4

# QUICK RECOVERY

The 1930s were great years for the Jayhawks as they compiled a 153-37 record for the decade, a winning percentage of 80.5 percent. After a 9-9 season in 1928 and KU's worst season in history in 1929, All-Americans Frosty Cox and Ted O'Leary led the 1930 Jayhawks to a 14-4 overall record and second place in the conference. For the next four straight years, KU won the conference title outright. After a dip to second place in 1935, the Hawks then finished first in the conference three more years in a row.

After winning the last two games in 1935, the 1936 squad went undefeated in the regular season, 20-0, and then won the first game of an Olympic Playoff series with Utah State, setting a then Jayhawk record of twenty-three straight wins. Unfortunately, Utah State won the next two games to end KU's Olympic bid.

It is interesting to note that KU opened the 1935 season with two games against Kansas State played with twelve-foot baskets, something for which Coach Allen had been lobbying for several years. Each basket on the higher goals counted for three points. KU lost the first game at home but won the second "experimental game" in Manhattan. Although the idea never caught on, Allen's passion for the twelve-foot basket continued for many years (until he landed Chamberlain).

# KANSAS UNIVERSITY BASKETBALL LEGENDS

## THEODORE "TED" O'LEARY (PLAYER: 1930–32)

*A renaissance man. A hero on and off the court.*

At the time of his death in February 2001, former sportswriter Ted O'Leary was one of the last links to basketball inventor James Naismith. Naismith taught physical education at KU for almost forty years, and O'Leary was one of his students. O'Leary played for Phog Allen, lettering all three years (1930–32). He started all fifty-one games KU played then, with a career average of 7.5 points per game. He came on strong his senior year, garnering All-American honors and leading the Big Six in scoring, with 11.1 points per game. To put that in perspective, KU averaged 30 points per game that year, on their way to a 13-5 overall record and first in the league. He was also the number one player on KU's tennis team and earned a Phi Beta Kappa key for academic excellence.

Born in Oxford, England, O'Leary was a hometown boy from Lawrence, and his father, R.D. O'Leary, was dean of the English Department at KU, teaching literature and writing for forty years. Following graduation, he compiled a 26-9 record in two years as head basketball coach at George Washington University. Declaring that "coaching wasn't for me," O'Leary returned to work as a reporter for the *Kansas City Times*. He was an avid reader of books and had over twenty thousand volumes in his house. He also wrote reviews of close to three thousand of them for the *Kansas City Star*, plus hundreds of feature articles for the *Star*'s editorial page.

He was also an accomplished handball player, winning over twenty regional titles, and was named to the National Handball Hall of Fame. Phog Allen had taught O'Leary how to play handball during his sophomore year, for a special reason. Whenever Phog suspected one of his players of having a beer, he would invite the culprit down to the handball court and proceed to run him ragged. Eventually, O'Leary ruined Phog's plot by whipping his coach. Then he went on to win sixteen Missouri Valley handball championships.

O'Leary was a co-author of *The Kansas Century: 100 Years of Championship Jayhawk Basketball*. In the 1940s and '50s, O'Leary edited a hobbyists' magazine and was considered such an authority in his field that he was asked to write the hobby segment for the *World Book Encyclopedia*. He also was a longtime Midwest correspondent for *Sports Illustrated*. One of his most memorable stories was on Stan Musial's final trip around the National League before he retired in 1963.

Ted O'Leary. *KU Spencer Research Library.*

Bill Mayer, *Lawrence Journal-World* contributing editor, was a longtime acquaintance of O'Leary. "Ted was a sensational athlete—basketball, handball, tennis—and had one of the fiercest competitive spirits you ever saw. He refused to accept defeat," Mayer said. "But he was so much more than that. Ted was an amazing intellectual with an incredible range of interests." Kansas University athletic director Bob Frederick called O'Leary "a wonderful gentleman and an important part of Kansas' basketball history. He lived 90 really productive years. We will all miss him greatly."

## WILLIAM CLAUDE "SKINNY" JOHNSON (PLAYER: 1931–33)

In 1929, Johnson graduated from Central High School in Oklahoma City, Oklahoma, where he was coached by George Rody, former star at KU of the 1920–22 seasons. Strangely, he was the third player in his family to play at Central High and be called "Skinny." His brother Clarence was the first "Skinny" as team captain in 1923 and brother Kenneth was another "Skinny" who graduated in 1927, leaving William to be "Skinny" until he graduated in 1929.

The dominant collegiate center of his time, Johnson led KU to three straight Big Six basketball titles during his varsity career. He earned all-

conference honors in 1932 and 1933 and achieved All-American status in 1933. At six-foot-four, Johnson was considered a giant and, with his great leaping ability, was particularly effective because of his ability to control center jumps in an era when the center jump after each basket was part of the game.

One of Phog's favorite stories, told over and over again each season until it became a legend, had to do with Skinny Johnson's heroic flight from his family's grave in the cemetery in Oklahoma City to the basketball court in Lawrence for a key game at the end of the 1932 season. On this particular Saturday night, Missouri, Oklahoma and Kansas were facing their final games in the Big Six conference championship race, with possibilities of a triple tie for honors. Kansas was scheduled to meet Oklahoma in Lawrence, and on the same night, Missouri was to meet Kansas State in Manhattan. If Oklahoma were to defeat Kansas, and should Missouri win at Kansas State, the Big Six would be deadlocked.

On Wednesday, Phog told the press, "If Bill Johnson doesn't break a leg, Oklahoma will be in for a busy Saturday night." That evening, at dinner, Phog received a call from a friend, informing him that Johnson's father had died suddenly. Bill left on the night train, and with him, so it seemed, went Kansas's chances for its third consecutive Big Six championship.

Athletic authorities at OU were besieged by the press to postpone the game until the following week so that the two teams would meet at full strength, but the Sooners wanted to play the game on schedule. The funeral for Johnson's father was set for 2:30 p.m. on Saturday, in order to accommodate relatives from a distance. The KU-OU game was scheduled for 8:00 p.m., so there was no way for Johnson to drive the four hundred miles after the funeral to get to the game.

On the day of his death, Bill's father was quoted in the local paper: "I hope Bill plays the game of his life Saturday night." This statement proved to be the real challenge in Bill's decision to try to get back to Lawrence for the game. Several offers from businessmen to sponsor a flight were turned down because strong headwinds made the trip seem too perilous to consider.

All day on Saturday, the press had announced that Johnson was definitely out of the game. During the pregame meal, not one player mentioned the possibility of Bill's coming. However, with just one hour left, Phog received a telephone call that Johnson had landed at a lighted airport thirty miles away and was taxiing to the gym. Radio reports of the game in Manhattan, which started at 7:30 p.m., were saying that K-State was leading Missouri by eight points.

# Quick Recovery

About ten minutes before game time, walking into Hoch Auditorium, who would show up but Bill Johnson? All at once, bedlam broke loose, and the crowd of 3,500 Kansas rooters went wild when Johnson appeared on the floor. Kansas players, stunned at first, showered their teammate with adulation.

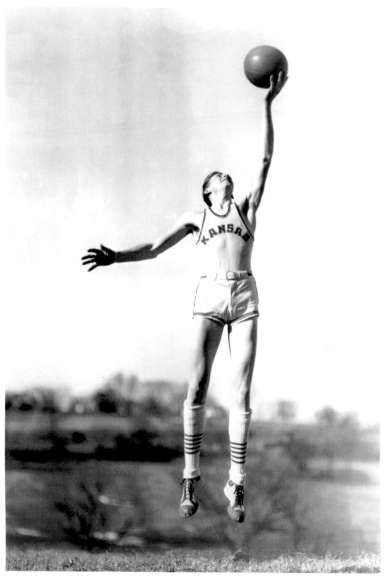

William Johnson. *KU Spencer Research Library.*

At the end of the half, radio reports announced that Missouri had won in Manhattan, so the next thirty minutes would tell if KU or OU would win the undisputed conference crown, and KU was enjoying a fourteen-point lead, 20–6. OU stormed out in the second half, scoring the first ten points, but they met Kansas on a night when Kansas's fighting morale was heightened, and KU won in a driving finish, 31–27.

In later years, Phog made this game a part of his storytelling repertoire, dramatically putting his hand to his ear as if listening for the droning plane. He not only had a good story with which to motivate future Jayhawks, but he also had his tenth conference title in fifteen seasons coaching at Kansas.

During Johnson's three-year tenure at KU, the Jayhawks had a 41-12 record, 22-8 in the Big Six, and three conference championships.

After leaving KU, Johnson went on to a great AAU career, playing for the Southern Kansas Stage Lines, which won the AAU national championships in 1934–36. He was one of the few men to ever receive All-American honors in high school, college and AAU basketball. He briefly coached basketball at Cleveland Chiropractic College in 1937, to championships of both the Naismith Industrial League and the Kansas City Independent Tournament.

Johnson received the Jim Thorpe Award, given annually to an all-time sports great from Oklahoma, and was inducted into the Naismith Basketball Hall of Fame as a player in the class of 1976. He died on February 5, 1980.

# THE WAR YEARS

D r. James Naismith died on November 28, 1939, nearly fifty years after inventing the game and three years after seeing it gain worldwide acceptance as an Olympic sport at the 1936 Summer Games in Berlin. Exactly three months later, on February 28, 1940, college basketball appeared on television for the first time when experimental station W2XBS in New York televised a Pitt-Fordham and Georgetown-NYU doubleheader at Madison Square Garden.

KU's 1940 squad, led by All-American Ralph "Cappy" Miller, achieved a three-way tie in the Big Six Conference and then won a playoff series with Oklahoma and Missouri. After beating Oklahoma A&M for the Fifth District title and then topping Rice and highly favored Southern California for the Western Division championship, the team advanced to the NCAA title game. The Indiana Hoosiers were too much for the Jayhawks, however, winning 60–42. Phog later reported that the 1940 team "had the necessary team work and qualifications to rank as one of the greatest KU teams of all time."

After Pearl Harbor on December 7, 1941, the Kansas University basketball team began its season with a December 17 victory at Denver. Military-bound players such as T.P. Hunter fashioned a 17-5 season record and won the Big Six co-championship but elected not to play in the NCAA tourney. Phog said, "My team is too small and too tired to partake of any post-season play, and besides, I want nothing to do with the NCAA."

When the Jayhawks finished the 1942 Big Six season 8-2 and in a tie for first, Allen had clinched at least a share of his twenty-fifth league title

in thirty-two years of college coaching. KU again beat Oklahoma A&M for the Fifth District NCAA title but lost to Colorado in the Western Division playoffs.

After the 1942 season, due to the many departures of students going off to war, collegiate basketball was in chaos and underwent dramatic change, foregoing many academic and team size requirements. The following year, the Jayhawks played nine games against military teams. Several members of KU's 1943 team that finished 10-0 in the Big Six enlisted after the season, including Charlie Black, Ray Evans and Otto Schnellbacher.

In 1943, Doc Allen began his "Jayhawk Rebounds," a series of eighteen treasured communications with his players and close friends in the armed forces. Allen, who also headed the Douglas County Draft Board, wrote to the guys about everything, reprinted some of their replies and compiled an ever-growing list of addresses so they could reach one another. After the death of a former player, he wrote, "Somehow this is the most difficult letter that I have ever attempted to write. Over a dozen times I have begun it and each time I have walked away from my desk because words fail me. I feel such a void. Something has gone from me. Your friend and mine—good, old honest 'Teep,' T.P. Hunter (1st Lt. 9ᵗʰ Marines), was killed on Guam, July 21, 1944. And yet this morning he feels closer to me than at any moment that I have known him." Sadly, Phog later learned that Wayne Nees, a 1938–39 basketball letterman who also took part in football and track, died on May 18, 1943, in Kiska.

The absence of KU's best players was obvious in the next season as KU fell to 17-9 overall and 5-5 in the Big Six. That 1944 team had twenty-two players on the roster, of whom only four stayed for the 1945 season. In 1945, twenty-seven different players were on the roster. After the war, Black, Evans and Schnellbacher all returned for the 1946 season, leading KU to a 19-2 record and a first-place finish in the conference. They averaged a school record fifty-six points per game. Unfortunately, they lost a close one to Oklahoma State in the NCAA tourney.

## Ralph "Cappy" Miller (Player: 1939–42): A High School Star

Miller was from Chanute, Kansas, where he earned four letters each in football and track, three in basketball and one each in golf and tennis at

Chanute High School. While in junior high, Bob Allen (Coach Phog Allen's son) informed his father that he had just scrimmaged against the finest player he'd ever seen. It was the first of several meetings between Ralph and the Allens. In a state tournament contest, Chanute High played a game right after Bob Allen's Lawrence High game. Miller had injured his hip during the first half, and Phog, an osteopathic physician, was asked to examine Ralph. Phog fixed him up, and Miller scored twenty-six points in the second half to lead Chanute to the state championship.

## Heavily Recruited

"I knew many schools were angling for Miller's services, but I did not use my advantage to endeavor to entice him to KU," Phog wrote in 1937. He didn't have to, as he had every indication that Miller was coming to Kansas, including the word of Miller's father, Harold. Phog had also coached Ralph's uncle Howard. Over seventy colleges heavily recruited Miller, including Stanford, which promised that his transportation costs to and from home would be handled. Stanford was coached by John Bunn, a former KU player and assistant coach. A wealthy Stanford alum flew Miller to Palo Alto, where he stayed at Bunn's home. Under pressure, Miller agreed to attend Stanford.

When Phog Allen heard of it, he arranged a summit meeting with Bunn and the Miller family at the Miller home, where Bunn had been waiting for two days to escort Miller back to Stanford. In the Miller house, the friendship between Allen and Bunn was severely tested. Allen not-so-tactfully reminded Bunn that while he was coaching the Kansas freshmen team in the 1920s, Phog had paid for part of his salary from his own pocket after the chancellor cut the basketball budget and that it was he who had gotten Bunn the Stanford job. "I told Bunn it was hardly sporting of him to come into Kansas and have Stanford men try to persuade Ralph to leave the state," Allen wrote in a 1937 letter. "I am pretty frank to say that I didn't handle him very easy in the last few minutes."

## A Three-Sport Star at KU

Allen got his man though, and Miller, a six-foot-one forward, went on to become one of KU's greatest athletes. During his freshman year, he had the honor of having Dr. Naismith as his physical education teacher. He was

the starting quarterback on the football team for three years, where he set school and conference passing records. His five touchdown passes against Washburn during his sophomore season still stand as a single-game record at KU. In track, he held the state low hurdle record and was on a path to be in the 1940 Olympics in the decathlon, but "Mr. Hitler got in the way and tried to blow up the world," Miller recalls. "So I never got to participate."

In basketball, he was a three-year starter for Phog, leading KU to the national championship title game in 1940, where the Jayhawks lost to Indiana. After sitting out the 1941 year with a terrible knee injury, he came back in '42 to lead the Big Six in scoring with 13.4 points per game, taking the Jayhawks to the conference title and to the NCAA tourney, where KU went 1-1. In a game that year against Wichita, Miller scored 30 points, setting the mark at that time for most points ever scored in a Kansas game. Overall, Miller played in fifty-nine basketball games and had a 10.2 scoring average.

## Becoming a Coach

During his junior year at KU, Miller approached Coach Allen mid-season with the suggestion to install an offense with a post man. Miller said that Phog didn't jump at the idea but subsequently had Miller play post in a scrimmage against Allen's traditional offense. They scrimmaged for two hours, with Miller's team winning. After a loss to Oklahoma, Allen called Miller to his office and informed him that he had decided to switch to the post offense. "We hadn't practiced it all season," Miller said, "but we used it the rest of the year."

Ralph Miller. *KU Spencer Research Library.*

In 1941, while sitting out the year with a knee injury, Miller coached basketball at Mount Oread High School, as a part of his practice teaching. The school was located on the KU campus and was attended mostly by children of KU professors. "There were perhaps 40 or 45 students in the place, maybe 15 or 16 boys. As professors' sons, they tended to be highly intelligent, but not endowed with an abundance of physical talent. I don't recall that we fared very well," Miller wrote in his book *Spanning the Game.*

Following his graduation from Kansas in 1942 with a degree in physical education, Miller served three years in the U.S. Air Force during World War II and was discharged at the rank of first lieutenant. He played semipro football and coached an AAU team but had no intentions of becoming a coach on a permanent basis. He tried several jobs that didn't work out. So when Wichita East High School called in February 1948, Miller began his coaching career, where he won sixty-three of eighty games and a state title in 1951. "The experience at East more or less changed my whole philosophy about coaching," he says. "It made me cocky. I could coach with these guys, and I spent the rest of my life doing it."

## *Coaching in the Big Time*

Miller went on to coach at Wichita State University, where he compiled a 220-133 record in fourteen seasons and achieved his master's degree. While there, he devised a system of full-court pressure defense that revolutionized the game and was the first coach to have his players press full court after every possession.

"I just have tremendous admiration for what he accomplished," WSU athletic director Jim Schaus said. "He embodies everything that is good about college athletics. He's one of the great coaches, if not the greatest, in the history of Wichita State basketball." Dave Stallworth, former Shocker All-American, said, "He was a teacher, a motivator, everything a coach should be."

Miller then took over the program at Iowa and finished there with a 95-51 mark in six years, winning Big Ten titles in 1968 and 1970 and taking the Hawkeyes to the NCAA tournament in 1971.

Miller went to Oregon State the next year, where he built the Beavers into a West Coast powerhouse. He coached there for nineteen years, compiling a record of 359-186, including four Pac-10 championships and eight NCAA appearances. He was twice named PAC-10 Coach of the Year and coached

Gary Payton, who later starred for the Seattle Supersonics. "Coach Miller is someone who believed in me and helped make me the player I am today," Payton said. "He always stressed defense and rewarded players who worked hard on the defensive end. That type of system gave me the confidence to succeed on both ends of the court."

## Hall of Fame

In 1988, he became the first active coach ever to be inducted into the Naismith Basketball Hall of Fame. At age seventy, Miller retired in 1989, ending his coaching career with the sixth most victories for a Division I coach, accumulating a record of 674-370 (64.6 percent). His teams had only three losing seasons in thirty-eight years as a college coach. "If I had to sum up my career, I'd say I was a pretty good teacher."

One of the last links to the root of basketball, Miller died on May 15, 2001, at his home at Black Butte Ranch near Corvallis. "This is a sad day for college basketball," Beavers coach Ritchie McKay said. "Ralph had a huge impact on the game and in young peoples' lives." Former Shocker player Leonard Kelley recalled, "He was a hero to me. Sometimes you think heroes will live forever, but nobody does." That may be the case, but his memory will live forever in basketball annals.

## CHARLES BRADFORD "CHARLIE" BLACK JR.
## (PLAYER: 1942–43; 1946–47)

Black certainly qualifies as a KU Legend because he is the only four-time All-American in Jayhawk basketball history. I believe that Tom Gola, who played at LaSalle from 1954 to 1957, is the only other collegiate player to do so.

Born in Arco, Idaho, Black lived in Hutchison, Wichita and Topeka before moving to Kansas City, where he attended Southwest High School. After spending a year studying agriculture at the University of Wisconsin, Black transferred to KU. During his first year, six-foot-five forward Black led the Jayhawks to a 17-5 overall record and sharing of the Big Six title. The Hawks lost in the first round of the NCAA tourney against Colorado, which was coached by KU Legend Frosty Cox.

Charlie Black. *KU Spencer Research Library.*

The next season, Black helped the Jayhawks to a 22-6 overall record and a perfect 10-0 conference mark, averaging 11.4 points per game. He, along with all-conference teammates John Buescher, Ray Evans and Otto Schnellbacher, combined with Armand Dixon to form the legendary "Iron Five." At the end of the season, almost all of the team members enlisted in the military services, forgoing any involvement in the NCAA tournament. If it hadn't been for World War II, KU would have almost certainly won the 1943 NCAA title that Wyoming eventually captured.

Charlie joined the Army Air Corps after the 1943 season and spent the next two years as a P-38 reconnaissance pilot, flying fifty-one missions with the rank of captain. He won the Distinguished Flying Cross.

Nicknamed the "Hawk" for his defense, Black returned to Mount Oread in 1946 and, picking up where he left off, led the Hawks to another perfect 10-0 conference record, while leading the league in scoring with a 17.3 average. The Jayhawks had an overall record of 19-2 and returned to the NCAA playoffs, where they lost to Oklahoma A&M, which featured seven-foot All-American Bob Kurland. That game also marked the radio play-by-play debut of Max Falkenstien, another KU Legend.

The 1947 season was a difficult one, as KU struggled to a 16-11 record, but Charlie still managed to earn all-league and All-American honors. He was the first KU player to score one thousand points for his career.

After leaving Kansas, Black spent a year with the Anderson Packers of the National Basketball League before moving to the NBA for two seasons, where he played for the Fort Wayne Pistons, Indianapolis Jets and Milwaukee Hawks.

Black had some success in farming in Kansas and managed a welding supply company before retiring in 1984 to Rogers, Arkansas. Shortly after his number ten jersey was retired, he died at age seventy-one, and the Jayhawks' locker room in Allen Field House bears his name.

## RAYMOND RICHARD "RAY" EVANS
## (PLAYER: 1942–43, 1946–47)

Ray Evans's accomplishments as a Jayhawk athlete would fill a large scrapbook. He holds the distinctive honor of twice being named All-American in both football and basketball and is the only athlete at KU to have both his basketball jersey (number fifteen) and football jersey (number forty-two) retired.

After a stellar high school career in basketball and football at Wyandotte High School in Kansas City, Evans enrolled at Kansas University and was named a basketball All-American his first two years. In 1942, Evans teamed with All-Americans Charlie Black and Ralph Miller, leading KU to a 17-5 record and a first-place tie in the Big Six. The following year, Evans and Black teamed with Otto Schnellbacher to take KU to a 22-6 record, undefeated in the Big Six.

On the gridiron in 1942, he led the nation in passing for 1,117 yards and once owned the NCAA record for sixty passes attempted without an interception. His KU record of 3,799 yards of total offense stood for over twenty years.

His collegiate career was interrupted by World War II, when he joined the U.S. Air Force. He returned to Kansas late in the 1946 season after being discharged, helping the Jayhawk cagers to a 19-2 record, a Big Six conference title and an NCAA tourney appearance. He played the full season in 1947, along with Black and Schnellbacher, but it was a tough season, with coach Allen out for much of the season with influenza.

He helped lead Kansas to a pair of Big Six football championships in 1946 and 1947. In 1947, he ran and passed for 1,018 yards, was named All-American and was the star of the 1948 Orange Bowl. He also played hellacious defense as a two-way performer. He holds the distinction of being the only NCAA football player ever to lead the nation in passing on offense and interceptions on defense in the same season. In fact, Evans is still the Jayhawks single-season (ten) and career (seventeen) leader in interceptions.

He was drafted by the New York Knicks in the

Ray Evans in a KU uniform. *KU Spencer Research Library.*

1947 NBA draft, but after being selected in the first round of the NFL draft, he played one professional season with the Pittsburgh Steelers. He was inducted into the Orange Bowl Hall of Honor in 1978, the Helms Foundation College Basketball Hall of Fame, the Kansas Sports Hall of Fame and the University of Kansas Athletic Hall of Fame. His gridiron number forty-two was retired in the late 1940s.

He later worked at Traders National Bank in Kansas City, where he served as president until he retired in 1975. While there, he was instrumental in bringing the Kansas City Chiefs to Kansas City and served as first president of the Chiefs Club. He also was a member of the Kansas State Board of Regents for twelve years and president of KU's Alumni Association from 1952 to 1953.

The Ray Evans trophy was established in 1968 to honor a member of each current Jayhawks football team whose all-around excellence on and off the field best exemplifies the traits of the former KU star. KU's football players practice on the Ray Evans Field in Anschutz Pavilion. His son Ray Darby Evans was a defensive back for the KU football team in 1981.

Ray was on hand at Allen Field House on February 22, 1997, to see his number fifteen jersey hung in the rafters of Allen Field House in front of 16,300 appreciative fans. "When I go to the games," Evans quipped, "I always look to the right and see the 'Beware of the Phog' banner. Now I'll have to look to the left, also." He died two years later on April 24, 1999.

## OTTO OLE SCHNELLBACHER SR.
## (PLAYER: 1943, 1946–48)

On March 10, 2008, the *Kansas City Star* reported, "Kansas lost a legend on Monday when Otto Schnellbacher, one of the greatest athletes in school history, died of cancer at the age of 84." Schnellbacher was one of the rare KU athletes to have played professionally in both the NFL and NBA.

Known as the "Double Threat from Sublette," the six-foot-four Schnellbacher played both football and basketball at KU, first in 1943 and then from 1946 to 1948, after returning from World War II.

In *Tales from the Hardwood*, Schnellbacher told about how Coach Allen had control of the team:

*He knew where we were every minute. When I was a freshman, we had to scrimmage against the varsity, and I had a good night against them. Afterwards, I got a note to see Coach Allen, and I thought, gosh, he's going to tell me how great I was. I got there and he asked me how school was going, and I told him fine, I was going to class and passing. He just stopped there and looked at me. "Otto," he said, "you can do three things on the campus. You can play sports, go to school, and chase women. You can do two of them well. Which two do you want to do well?" Then I remembered I had a fraternity coke date recently but said, "I'm not chasing any women." He then asked me, "Well, Miss Sweeder goes, doesn't she?" And I said, "Who?" I couldn't even think of her name for a minute. He said, "Miss Sweeder." Then I said, "She's gone." And he said, "I want you to call her up and tell her." I said, "I don't have her telephone number." And he said, "Well, I do." So he got command of me pretty quick. From then on, the girls were gone.*

Teaming with Charlie Black and Ray Evans in basketball, Otto was a four-time all-conference selection, averaging 11 points per game for his career. "Phog Allen liked football players," said Schnellbacher. "He liked toughness,

Otto Schnellbacher. *KU Spencer Research Library.*

people who could knock people down." Former basketball teammate Jerry Waugh said, "The thing that stood out about Otto was his leadership. You better give 100 percent on every single play or you had to answer to him." Schnellbacher served as both class president and team captain while at KU.

A three-year letterman and two-time all–Big Six selection on the gridiron, he was an All-American football selection in 1947 as a wide receiver, helping the Jayhawks to an 8-1-2 record, a share of the Big Six championship and a trip to the Orange Bowl. On the receiving end of Ray Evans's passes, he finished his football career as KU's all-time leader in receptions and receiving yards, marks that stood for twenty-two years. "He was very, very, very competitive," said former KU football teammate Cliff McDonald. "He was all gung-ho to win, never played around. When we played a ballgame, it was win or know why."

After graduating, Schnellbacher spent the 1948–49 season in the NBA with the St. Louis Bombers and the Providence Steamrollers.

He was drafted by the NFL Chicago Cardinals in 1947 and by the New York Yankees of the All America Football Conference in 1948, whom he joined for the '48 and '49 seasons. He then played for the New York Giants in 1950 and 1951, earning All-Pro honors as a defensive back both seasons. He led the NFL in interceptions with eleven in 1951.

After his athletic career, Otto lived the rest of his life in Topeka, Kansas, where he sold insurance for forty years and served as president of both state and national organizations of agents and underwriters. Waugh said, "Otto probably had all the fun he could stand as an athlete and just felt like he needed to get on with his life and got into the insurance business."

He never stopped working for his alma mater, according to friends. He served as the first president of the K-Club and kept the Quarterback Club strong in Topeka through the years. He served KU as a Greater University Fund Advisory Board member and served on the Gold Medal Club for the KU Alumni Association.

Schnellbacher is one of fifteen former KU football players whose name is displayed in the Ring of Honor around the top edge of Memorial Stadium. He has been inducted into the Kansas Sports Hall of Fame and the Kansas University Hall of Fame. KU and the Alumni Association also conferred the Distinguished Service Citation to Otto for his significant contribution to humanity.

Schnellbacher died of cancer on March 10, 2008, at age eighty-four.

# BACK ON TOP

It began with a preposterous promise: come to Kansas and win a national championship and wear an Olympic gold medal. In 1948, that was the heavy-duty recruiting pitch by KU coach Phog Allen and assistant Dick Harp. Dick said, "Doc, are you sure you want me to say that?" and Doc told him, "Absolutely." Allen was plotting his return to prominence after several down years and retirement on the horizon. Their efforts that year resulted in obtaining commitments from a group that helped make him a prophet.

That bunch led KU to a first-place tie in the Big Six Conference in 1950 and a 16-8 record in 1951. On a trial basis for the 1951 season, teams were given the option of taking the ball out of bounds or shooting free throws after a foul. In a game against St. John's, KU waived twenty-six free throw attempts. With thirty-nine seconds remaining, and St. John's ahead 51–50, KU waived a free throw and took the ball out under its own basket. Bill Hougland's shot bounced around the rim, and big Clyde Lovellette tipped it in for the win. "Teams profit by fouling you," Allen said. "I don't want them to have the ball. I want to show that the foul is too cheap."

On March 26, 1952, the Jayhawks arrived at the highest point in the program's storied history, winning KU's first NCAA championship before a disappointing crowd of ten thousand at Edmundson Pavilion on the University of Washington campus. A few months later, Allen's promise was fulfilled when a Kansas-loaded team captured the gold medal in the Olympics.

With Lovellette and the nucleus of the 1952 team graduated, hardly anyone expected they would be close the next year. So when KU came within

one basket of another NCAA title in 1953, Don Pierce called that team the "most astounding basketball season in Mt. Oread Annals." B.H. Born led the conference with a 22.5-point average, and Dean Kelley captained the Jayhawks to the conference title. After beating Oklahoma City, Oklahoma A&M and the Washington Huskies, they dropped the title game to Indiana in a 69–68 thriller.

## WILLIAM MARION "BILL" HOUGLAND (PLAYER: 1950–52)

Bill Hougland was the first basketball player in Olympic history to win two gold medals, something he accomplished at the 1952 games in Helsinki, Finland, and the 1956 Olympics in Melbourne, Australia.

Hougland was born in Caldwell, Kansas, in 1930 but moved to Beloit before the start of the 1946–47 school year. The six-foot-four junior Hougland became one of the state's best players, leading Beloit High School to the Class A state championship game that year and the following year. After graduating, Hougland agreed to the promise of the heavy-duty recruiting pitch Allen gave to him and his future teammates Clyde Lovellette, Bill Leinhard and Bob Kenney in 1948.

At KU, he played in seventy-seven games as a three-year starter. The 1950 and '51 teams improved each year before really jelling his senior year, in 1952.

Phog Allen once said:

> Now one of our best players was Bill Hougland. I coached Bill for four years at Kansas, and I learned what makes him tick. I knew him as a boy, dedicated to giving himself to a cause in which others were involved—in sports such a boy is known as a player's player. There was an utter simplicity about everything Bill did—about his living habits, in what he said, in how he acted. Yet Bill owned a fiery side and was, in every sense, a competitor. He got out of sports as much as any boy I ever knew. Bill's spirit was our spark plug.

At the end of the conference season in 1952, KU whipped K-State to tie for the Big Seven lead and then won the title outright by downing Colorado at Boulder. The bad news was that Hougland received a deep bruise on

his left thigh during the K-State game and wasn't able to do much at Colorado. Hougland hobbled through the tournament victories over TCU, St. Louis and Santa Clara, but he remained doubtful on the eve of KU's title showdown with St. John's in Seattle. Ailing as he was, the determined Bill scored five points, bagged six rebounds and played fierce defense, leading KU to an 80–63 romp, for KU's first NCAA championship.

After the season, the team went on to beat Southwest Missouri and LaSalle and then lost by two points to the AAU champion Peoria Caterpillars, but they earned seven spots on the U.S. Olympic team. Hougland was the outstanding player throughout the Olympic games. It was his clutch play in the finals against

Bill Hougland. *KU Spencer Research Library.*

Russia that turned the tide. With the score tied 15–15, he cleared a rebound, dribbled down the court, pulled up and scored just before the buzzer ended the first half. The Jayhawk-dominated team went on to down the USSR, 36–25, in the gold medal game.

After leaving Kansas, Hougland went to work for Phillips Petroleum Company and played for the Phillips 66 AAU basketball team, which won the Olympic Playoff in 1956, qualifying for the Olympic Games in Melbourne, Australia. The U.S. team won gold again as Hougland, the team captain, brought home his second medal. "We blew out everybody. Nobody came close. Nobody had ever seen anybody like (Bill) Russell," Hougland said of the Boston Celtics Hall of Fame center and his teammate in '56. "He made things easy because you overplayed everybody on the outside. If they got by, you knew Russell would take care of 'em. He was fun to play with."

Hougland played AAU ball for two more years and then left Phillips in 1961 to work for Koch Industries, later becoming president of Koch Oil, for thirty years before retiring in 1991.

Hougland was appointed to the Kansas All-Sports Hall of Fame Board of Trustees. He and his wife, Carolie, donated $1.2 million to KU to assist four programs at the university. For several years, he was a member of KU's Board of Advisors. He now lives in Lawrence. In 2006, he was inducted into the Kansas Sports Hall of Fame.

## CLYDE EDWARD LOVELLETTE (PLAYER: 1950–52)

Perhaps no one in college basketball history dominated the sport as completely as Lovellette did during the Jayhawks' drive to the 1952 title. *Time* magazine reported that Clyde "galloped up & down basketball courts in the N.C.A.A. tournament with all the intensity, if not the ferocity, of a rampaging bear." In four games against some of the United States' best teams, using an apparently unstoppable hook shot, Lovellette demolished every major NCAA scoring record by swishing 141 points through enemy baskets. His 44 points in the second round against St. Louis set an NCAA tourney record, and his 33 points against St. John's in the title game paved the way for an easy 80–63 championship victory.

The youngest of eight children, Clyde was born in Petersburg, Indiana, to John and Myrtle Lovellette on September 29, 1929, but he was raised in the manufacturing town of Terre Haute. His father was a New York Central Railroad engineer.

He grew into a gangly teenager, standing six-foot-four as a high school freshman, and was painfully awkward and shy because of his height. "I was so awkward in high school; Mom got me a skipping rope and told me to go to it," Clyde reminisced. By his junior year, his coordination was catching up with his enormous frame. "I'd go to bed with the right length of pants," he said laughing. "I'd wake up and the suckers would be too short." No longer the self-conscious introvert, Lovellette blossomed on the court, earning all-state honors as a junior and senior.

Basketball was something he always loved. His growth spurt put him at six-foot-nine, 240 pounds by his senior year, and he attracted the attention of many major colleges. He led his Garfield High School team to the 1947 state championship game. "You'd go to bed with a basketball. You'd wake up with a basketball. Girls were a foreign object."

It was assumed he would stay close to home, playing collegiate ball in hoop-crazed Indiana, and he originally committed to Branch McCracken,

coach at Indiana University, only to find the environment too large and intimidating for his taste:

> *Phog was going to make a speech in St. Louis and then came to Terre Haute to meet with me instead of going back to Lawrence. I really didn't want to meet with him because I had verbally committed to Indiana. But I decided to meet him, and that's when he made the one statement that no other coach had ever made—he said that if I came to KU the team would be good enough to win a national championship. He also predicted that we would go to the Olympics together.*

"It was a beautiful idea," Lovellette decided. "That had a huge impact on me. I changed my mind because of that talk."

Lovellette suffered from a slight case of asthma. Among Phog Allen's attributes was his sense of humor. When asked why Lovellette wound up at Kansas, Phog told the *Kansas City Star*, "One big reason Clyde enrolled here was because the altitude helps his asthma. Up here on the hill a tall man can stand up straight and breathe the rarified atmosphere."

## *At Kansas*

The chemistry between Coach and Lovellette was immediate. Allen was the mentor Lovellette had been seeking. For Clyde, Kansas turned out to be the absolute best place in the basketball universe.

Because freshmen weren't eligible, he spent his freshman year growing both as a person and as an athlete, further honing his skills under the tutelage of Allen. "We worked very hard during our freshman year, and then we stayed there during the summer and worked on various skills. So once we took to the court during our sophomore year, we felt that we were ready to play college basketball." As a sophomore, Lovellette proved to be everything that Allen had predicted, finishing fourth in the nation in scoring, with a 21.8 per game average; being named All-Big Seven; and garnering the first of three All-American honors.

His junior year was equally successful, as he improved his scoring average to 22.8 points per game, fifth in the nation, and another All-American selection. Opposing defenses keyed on him, but he used the tactics to his advantage, developing the deadly outside hook shot that would later become such an effective weapon in the NBA.

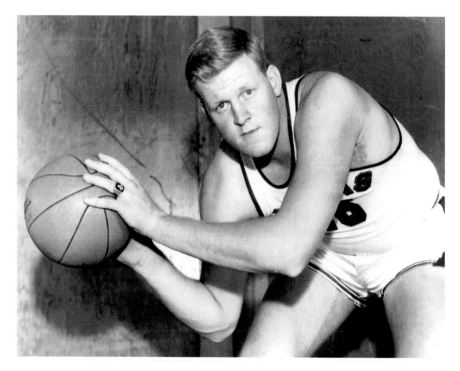

Clyde Lovellette. *KU Spencer Research Library.*

His nice big smile, his salute and his motorcycle were popular sights on the Jayhawks campus. While at KU, he hosted a radio show called *Hill Billy Clyde and His Hound Dog Lester.*

As predicted by Coach Allen, everything did come together for Lovellette and the Jayhawks during the magical 1952 season. Clyde led the nation in scoring with 28.4 points per game. "It seemed like from the first time we stepped on the court that year against Creighton, good things were going to happen," Lovellette told the *Kansas City Star* in 1988. "It just all came together. It was a great experience. I don't know if you can call it providence, but we were determined to fulfill the prophesy that Phog had given us. We came together, and the team as a whole was unstoppable."

As the team was flying to Seattle for the Final Four, its plane encountered some rough turbulence. Allen hated to fly, so Lovellette calmly took some artificial flowers that were aboard and placed them in the sleeping coach's hands. "When coach woke up, I said, 'Relax, Doc. If we crash, you've got a good suit on, and they can take you right to the funeral home.' That loosened him up."

Actually, in retrospect, the toughest time Kansas had came the night before the tournament, when Clyde went out for the evening and was missing all night. A fraternity brother of Clyde's had become an ensign in the coast guard and was stationed in Puget Sound. He invited Lovellette for a cruise on Lake Washington, and when they tried to return to Seattle, a dense fog had set in, delaying his return until the following morning.

He was named Helms Foundation College Player of the Year and left Kansas as the school's all-time scoring and rebounding leader, with 1,888 points and 813 rebounds in seventy-seven games (records subsequently surpassed by current leader Danny Manning).

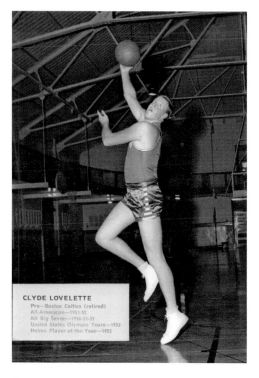

Clyde Lovellette hook shot. *KU Spencer Research Library.*

## *Olympics*

Lovellette and six KU teammates were selected to represent the United States on the Olympic team, with Allen being named an assistant coach. "What a great honor to represent your country," Lovellette said. "Going to the Olympics was the biggest thrill of my entire basketball career. No longer was I representing a single state. I was representing millions of Americans with my behavior, my ability and my performance on the basketball court. That meant a lot to me. Winning the gold medal was icing on the cake."

The Americans opened with wins over Hungary, Czechoslovakia and Uruguay before meeting the Russians in an aggressive and physical battle, which resulted in an 86–58 win behind fourteen points each from Clyde and KU teammate Bob Kenney. After three more wins, they were again matched up against the Russians, in the gold medal game. The USSR, learning from

their earlier loss, stuck to a strategy of tight defense and a full-court stall. At halftime, the Americans had managed only a 17–15 lead. The Reds gained the lead early in the second half, but the Americans started hitting their outside shots and eventually won 38–25, with Lovellette leading the American offense with nine points.

## Pros

After a season playing AAU basketball for Phillips Petroleum in 1953, Lovellette signed with the Minneapolis Lakers. Playing solidly as a rookie, behind the great George Mikan, Lovellette was an important factor in the playoffs, averaging 10.5 points and 9.7 rebounds in thirteen playoff games. The Lakers won the NBA title, and Clyde became the first player ever to win a championship at all three levels:

> *I didn't know too many players in the pros. I had to read about George Mikan to find out what everyone was talking about. And then meeting him at that first practice was an awesome sight, because George was a full inch taller than me and outweighed me by at least twenty-five pounds. He was all man.*

After four years with the Lakers, Lovellette was dealt to the Cincinnati Royals, where he toiled one year, scoring 23.4 points per game, fourth in the league. At season's end, he asked to be traded and landed with the St. Louis Hawks, teamed with Hall-of-Famers Bob Pettit and Cliff Hagan. "The three of us just gelled together. We were the top-scoring frontline in the NBA for the four years I was there." While a Hawk, he registered two All-Star appearances. In 1960, the Hawks bowed to the Celtics in seven games for the NBA title and lost again to the Celtics in five games the following year.

Red Auerbach of the Celtics picked up Lovellette for the 1962–63 season to provide backup relief for Bill Russell. Lovellette played solid basketball over the next two seasons, helping the Celtics win two more NBA championships. "It was really special to be a part of the Boston Celtics."

In a 2010 interview, Dolph Schayes, the old Nats' hero who spent most of the 1950s and some of the '60s dodging Clyde's elbows, said, "Lovellette was a character. And he loved guns. Remember, those were the days when all those Westerns were on television. *Bonanza* and stuff like that. Everybody was drawing guns back then on TV and in the movies. Well, Lovellette loved that

stuff." Loved it so much that he traveled with six-shooters. And wore cowboy duds. And hoped to become the next John Wayne out there in Hollywood once his basketball career ended.

Why, Clyde Lovellette loved the Old West thing so much that one night in Lubbock, Texas, where his St. Louis Hawks had played an exhibition game, he paid a visit to the hotel room of Willie Smith, who'd served as a referee in the contest. And when the unsuspecting Smith answered the door, Lovellette pulled two pistols from the holster he was wearing and fired them.

*Bang! Bang!* And Smith reached for his gut. "But," said Schayes, "they were blanks. They weren't real bullets, but they made a lot of noise and almost scared Willie to death."

And just like that, Lovellette—who'd practice his draw, with real guns and holsters, in front of hotel room mirrors—saw the legend of his cowboy eccentricity grow. "Everybody in the league heard about it," Schayes said. "Everybody knew what happened. And everybody laughed like hell."

He retired in 1964, after eleven seasons in the NBA, saying the train travel and rigorous schedule had worn him down. "I got tired. We played on the average of five games a week, and in between you'd travel. I learned a lot and I experienced a lot." He finished his career with 11,947 points (17 points per game) and 6,663 rebounds (9.3 per game).

## *Retirement*

Back home in Terre Haute, Lovellette worked as a radio and television announcer. Then he realized a boyhood dream of being elected sheriff of Vigo County, where he won the election by eight thousand votes. He took office in 1967 and made good on a campaign promise to close down a red-light district and some gambling dens before being defeated after one term.

He returned to radio, raised cattle and then headed east to Massachusetts, where he taught history and coached basketball at St. Anthony's Catholic School for a year before the school closed. After a stint as head of an Indiana country club and a failed bid to be elected mayor of Terre Haute, he was hired as a teacher by White's Residential and Family Services, a Quaker-run childcare facility helping troubled youth. Lovellette said he found his calling helping children. He stayed at the school until he retired in 1995.

During several northern Michigan camping trips, the Lovellettes bought a house in Munising and a cabin on Sixteen Mile Lake, where Clyde loved to fish. He served as Munising city commissioner.

In May 1988, Clyde received basketball's highest honor: enshrinement in the Naismith Memorial Basketball Hall of Fame. He is also a member of the Indiana Basketball Hall of Fame and Kansas Sports Hall of Fame. Clyde's number sixteen jersey was retired in a ceremony honoring the 1952 NCAA championship team on February 15, 1992, and he was inducted into the National Collegiate Basketball Hall of Fame on November 18, 2012.

## DEAN EDWARDS SMITH (PLAYER: 1951–53)

*He's the most famous bench-warmer in Kansas basketball history.*
*—Pete Goering,* Topeka Capital-Journal

As a little-used reserve forward on Kansas's great 1951–53 teams, Dean Smith certainly does not qualify as a basketball great on the basis of his production on the court. His results on the court sidelines, and his gold

Dean Smith as a young man. *KU Spencer Research Library.*

standard reputation on and off the court, however, most certainly qualify him as one of KU's biggest Legends. While Phog Allen is called the "Father of Basketball Coaching," Dean Smith could arguably be called the "Father of Modern Hoops."

Born in Emporia, Kansas, Dean was the younger of two children of devout Baptist schoolteachers. His father Alfred was a forward-thinking coach at Emporia High, winning the state title in 1934 with the first black basketball player in Kansas tournament history. The school board there told him not to do it, and he said, "No, I'm going to do it, or I'm going to resign." They

won the state championship, and then nobody complained about having an integrated team anymore.

Just in time for Dean's freshman year, the Smiths moved to Topeka, where he played for the Topeka High Trojans, my alma mater. He played quarterback on the football team, lettered as a catcher on the diamond and played point guard on the hard court.

Though he played basketball at KU, he went there on an academic scholarship, majoring in mathematics. It was at Kansas where he made valuable use of his time observing the finer points of the game from legendary coach Phog Allen. An all-around athlete, he also played freshman football and varsity baseball for the Jayhawks.

Teammate B.H. Born recalled in *Tales from the Hardwood* that both he and Dean had to work for their scholarships, which gave them a bed, board, books, tuition and fifteen dollars a month:

> *When they were passing out jobs, they got down to the last two, and it was between Dean and me as to who got which. He was a year ahead of me. So he got the first choice. He chose to be an assistant coach on the freshman team. The other job was handing out towels down in the locker room. So, I guess I came within about two towels of being the coach at North Carolina.*

After graduation, Dean served one season as a graduate assistant coach at KU before joining the U.S. Air Force. "Everyone understood that he was going to be a coach," observed Rich Clarkson, *Lawrence Journal-World* reporter. Lieutenant Smith coached his base team in Germany and hoped to find a high school job in the States after his tour of duty was up. However, at a service tournament, he became acquainted with Bob Spear, who had just been named coach at the Air Force Academy, and Spear offered him a job as assistant. While at the academy, Smith also served as head coach of the baseball and golf teams. Three years later, Frank McGuire offered him an assistant's position at North Carolina.

McGuire's lavish recruiting style eventually got the Tarheels in trouble with the NCAA, so in 1961, UNC let him go and hired thirty-year-old Smith to replace him.

Smith's first few teams were nothing special. When he took over the reins, the basketball program was on probation, restricted in recruiting and scheduling. He began with a losing season. It was said that that team produced more lawyers (nine) than wins (eight). After several mediocre seasons, Smith was burned in

Dean Smith at North Carolina. *KU Spencer Research Library.*

effigy on campus in 1965. But by the time he retired in 1997, he had compiled an 879-254 mark, becoming the winningest coach in the history of the game and certainly one of its most respected.

During his thirty-six years as head coach at UNC, he became the winningest coach in the history of the NCAA tournament, with sixty-five victories; his teams qualified for the NCAA tournament a record twenty-three consecutive years; his teams won thirteen ACC championships; and his squads made it to the Final Four eleven times and won two national championships. He was named National Coach of the Year four times and voted ACC Coach of the Year eight times.

Before 1982, Smith was always a bridesmaid, never the bride. Six times he went to the Final Four, and six times he came away empty-handed. He gained the rep that he couldn't win the big one. That was finally laid to rest in 1982, when the Tarheels were composed of future NBA players Michael Jordan, James Worthy and Sam Perkins. In the now-famous title game against the Georgetown Hoyas, led by the great Patrick Ewing, Jordan made the game-winning jump shot with seventeen seconds left on the clock. Smith gained his second national title in 1993. After defeating Kansas in the semifinals, North Carolina played Michigan's "Fab Five" and won when the Wolverines received a technical because Chris Webber called a timeout when his team had none left.

Smith was particularly adept at adapting to the style of play that best suited his players and is recognized as one of the great minds of the game, being credited with many innovations, including the four-corners offense, the scramble defense, the practice of huddling at the free throw line before a foul shot, starting all the seniors on the last home game of the season and

the practice of saving timeouts for end-of-game situations. Smith's teams executed the four-corners set so effectively that in 1985, the NCAA instituted a shot clock to speed up play and minimize ball-control offense.

Smith surpassed Adolph Rupp's winning record on March 15, 1997, with his 877th career victory. He deflected credit, choosing instead to dedicate the achievement to those who had come through his program. "I want to recognize all the assistants who coached with me and all the players who played for me. I don't have to name them all, but I could do it. They all share in this moment." Former All-American Phil Ford said, "I knew when I signed with North Carolina that I was getting a great coach for four years, but in addition, I got a great friend for a lifetime."

Just in terms of former players, Dean Smith's influence on the game's present and future is immeasurable. After playing for him, forty-eight former players have gone on to play in the NBA or ABA. Tarheels who have made a mark in coaching include: Larry Brown, Billy Cunningham, George Karl, Eddie Fogler, Phil Ford, Roy Williams, Matt Doherty, Buzz Peterson and Jeff Lebo, as well as many others not so well known.

The basketball arena at UNC is officially the Dean E. Smith Student Activities Center but popularly known as the "Dean Dome." No basketball program besides North Carolina's has been more heavily influenced by Dean Smith than the one at Kansas University. Coach Smith is credited for KU hiring Larry Brown, convincing Athletic Director Monte Johnson to hire Brown in 1983. And when Brown left after guiding KU to the 1988 NCAA championship, Smith promoted the hiring of Roy Williams. Both had played under Smith, and Williams was his assistant for twelve years.

Smith received a number of honors during his coaching career. He coached the U.S. team to a gold medal at the 1976 Summer Olympics in Montreal, and he was enshrined in the Naismith Memorial Basketball Hall of Fame on May 2, 1983. In 1997, he was named *Sports Illustrated* magazine's Sportsman of the Year because "his teams won, his players graduated, and the rules went unbroken." And in October 1997, *Sports Illustrated* dedicated an entire issue to Smith, as a tribute to his thirty-six years of Carolina basketball. Smith coached nine consensus first-team All-Americans and thirteen Olympians, an incredible 96 percent of his players graduated and, like his mentor Phog Allen, he always kept in touch with every one of them. In November 2008, he was a recipient of the distinguished North Carolina Award, the highest civilian honor the state can bestow.

When Smith came to coach at Carolina, the Atlantic Coast Conference still was all white. However, he championed racial equality both on and off

the court. He played a large part in desegregating the city of Chapel Hill, first by helping to integrate the Pines, a local restaurant where the team ate its meals, and then when he integrated the basketball team by first recruiting Willie Cooper, a walk-on in 1964, and then recruiting Charlie Scott as the university's first black scholarship athlete. In 1965, Smith helped Howard Lee, a black graduate student at North Carolina, purchase a home in an all-white neighborhood. Four years later, Lee became the town's mayor.

At KU's basketball centennial celebration in 1998, a packed crowd at Allen Field House gave big Clyde Lovellette, the leading scorer on the 1952 team, a rousing ovation, but the loudest cheers were reserved for the backup guard who played a total of twenty-nine seconds in KU's victory over St. John's for the '52 NCAA title.

*If basketball had a Mount Rushmore, Dean Smith's face would be on it.*
*—Jay Bilas, former Duke star on ESPN Classic's* SportsCentury

# THE 1960S

The 1960s started off with promise, as the Bill Bridges–led 1960 team finished first in the Big Seven conference and beat Texas in the NCAA tourney before losing to Oscar Robertson's number one Cincinnati in the Midwest Regional. Then the bottom dropped out, as the NCAA slapped the football and basketball teams with probation in October 1960. The NCAA charged that KU boosters had purchased a used car valued at $1,564 for Wilt Chamberlain and ruled the basketball team ineligible for postseason play for two years. After that, player disappointment, transfers and inadequate recruiting created a steady decline, leading to Coach Dick Harp's resignation after the 1964 season.

After a mid-season loss to K-State in 1964, Harp was hanged and burned in effigy on campus. After a twenty-one-year relationship with Kansas basketball as either a player or coach, Harp left the university. "I have determined that it is time for me to retire from coaching," Harp said in announcing his resignation. "My association with the University of Kansas has been a wonderful experience. From the time I was a little boy, the biggest thing in my life was the University of Kansas," Harp told the *Topeka Capitol-Journal*.

Things started looking up for the remainder of the '60s, though, with the commitments of Walt Wesley and JoJo White, resulting in four back-to-back twenty-plus seasons.

## WALT WESLEY
## (PLAYER: 1964–66; ASSISTANT COACH: 1978)

*In the 1960s, if you were black and of high school age, you attended Fort Myer's Dunbar High, Lee County's all-black high school. White kids went to Fort Myer's High School; segregation was a way of life. We had hand-me-down books and equipment. Colleges in Florida were not accepting applications from black athletes.*
*—Walt Wesley*

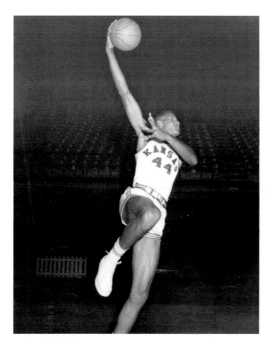

Walt Wesley hook shot. *KU Spencer Research Library.*

Lucky for KU, Wesley committed to the Jayhawks. After leading the freshman squad in scoring in 1963, things were looking up for the Jayhawks in his sophomore season. Expectations were high, as he was teaming up with George Unseld, the team's leading scorer and rebounder the year before, and senior star Al Correll. The year turned ugly, however, when coach Harp was hanged in effigy mid-season, Wesley was declared ineligible for the second semester and Correll finished his career eligibility in December. The team finished 13-12. Harp was fired at the end of the season, and assistant Ted Owens was promoted to head coach.

Six-foot-eleven Wesley came on strong in the following season, though, leading the team in scoring (23.5 per game) and rebounding (8.8 per game). Coach Owens said, "He was an enormous worker who grew and grew. At K-State his sophomore year, he scored 28 points. His junior year he had a career big game against Loyola (42 points, eighth-best mark in KU history). He played against St. John's and scored 38 in Manhattan, and the New York papers called him the 'New Wilt.'" The Jayhawks finished second in the conference, won the conference tourney and finished 17-8. Walt was named All-American.

The 1966 team was special. After going 15-3 at midterm, coach Owens said, "We knew we had a good team." After JoJo White joined the team for the second semester, the Jayhawks won seven straight games to take the conference title outright. After defeating SMU 76–70 in the first game of the NCAA tourney in Lubbock, Texas, the Jayhawks faced Texas-Western (now UTEP). That's where, in a game made famous later in the movie *Glory Road*, Walt set a pick for JoJo, who swished a thirty-footer as the buzzer sounded. And then—the whistle. An official's call wiped out the basket, costing KU an 81–80 double-overtime loss to the Miners. "To this day, I don't think he stepped out," said Walt. Replays clearly show White was in bounds. Remember, they were playing in Texas, and referee Rudy Marich was from Texas—so go figure. Miners coach Don Haskins said, "Kansas was the best team we faced, by far. If we hadn't beaten Kansas, they could have won the national championship."

For the year, Walt scored 20.7 points and grabbed 9.3 rebounds per game and was again named All-Big Eight and All-American. He finished his KU career with 1,315 points (19.3 average) and 565 rebounds (8.3 average).

He was a first-round pick of the old Cincinnati Royals and spent ten years playing for eight teams in the NBA. He finished his career with 4,998 points and then returned to KU, where he became an assistant under Ted Owens for one season.

After getting his degree in education, Wesley coached as an assistant at Western Michigan and then at the U.S. Military Academy in West Point before coming home to Florida for good in 1995 to operate several programs for the Fort Myers Parks and Recreation Department. Then he began his work as executive director of the Police Athletic League, an athletic and educational program for at-risk children.

KU honored Wesley by retiring his number thirteen jersey in December 2004. "Without a doubt, it's one of my greatest thrills. It's quite an honor, especially at the University of Kansas, to have your jersey hung in the rafters," Walt said that night. "I have such great and fond memories of being there and playing in Allen Field House."

## JoJo White
## (Player: 1966–69; Assistant Coach: 1983 )

Joseph Henry White grew up in St. Louis. He was the youngest of seven White children. White acquired his nickname while attending McKinley

High School. He had a tendency to doze off while Coach Jodie Bailey was giving chalk talk sessions. It always took two calls—"Jo! Jo!"—to bring him to life.

On a recruiting trip to Lawrence, White watched the Kansas football team, led by Gale Sayers, knock off nationally ranked Oklahoma, 15–14. Of Sayers, White said, "I was in awe of him, and watching him perform was a huge thrill for me, and the game was definitely a big influence in my decision to attend Kansas."

White became eligible to play at the start of the spring semester of the 1965–66 school year. Head coach Ted Owens had one of his best teams but wrestled with the perplexing question of whether to play White that year. "We had all of the other pieces of the puzzle covered," said Owens,

> but he was such a great talent who just added so much speed and ball handling and versatility. What we sensed was that this was a team that could win the national championship. I asked JoJo what he wanted to do, and he said, "I want to play right now." I talked to our captain—Riney Lochmann—and I said, "Riney, we're trying to make a decision about JoJo. JoJo wants to play. He feels we have a great chance, and I feel that we have a great chance to win the national championship. But one thing is important, if he plays he will be a starter and that means that you may not start." Riney said to me, "Coach, it doesn't matter whether I start or not. We think JoJo can help us to win the national championship, and we want him to play." That sealed it as far as I was concerned, because in Riney Lochmann and Del Lewis, who were our captains, we had two great young men and two very unselfish players. So with their endorsements and with JoJo wanting to, we made that decision.

JoJo adjusted rapidly to Owens's ball-control system, becoming the guard that coaches dream about—a staunch defender, devastating outside shooter and able to break down the opposition. In short, he could do it all, and Kansas won its last seven games of the season, winning the Big Eight title outright and gaining entry to the NCAA tourney.

As it turned out, Owens's decision was somewhat of a mistake, as KU was jobbed in the regional final game against eventual champion Texas Western. White's long jump shot at the buzzer appeared to give the Jayhawks an overtime victory. "I remember having the ball in my hands and taking that final shot. I fell back into a woman's lap after the release, and I remember the crowd and my teammates celebrating after the shot went in. Then the

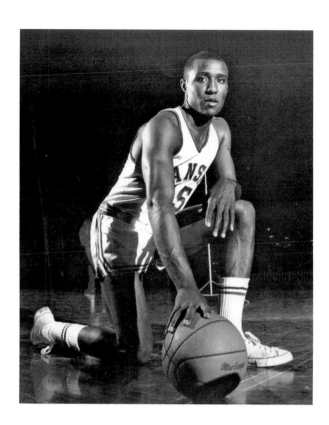

JoJo White. *KU Spencer Research Library.*

official ruled that my foot was out of bounds." Texas Western then went on to its historic 1966 championship win over Kentucky.

An all–Big Eight selection in 1967, '68 and '69, the six-foot-three White was the heart and soul of Jayhawks teams that made two NCAA and two NIT appearances. He was also a two-time first team All-American and played on the U.S. team at both the University Games and Pan-American Games, and his performance on the 1968 U.S. Olympic gold medal team brought him international fame. "My biggest thrill came in the Olympics," White told the *Topeka Capitol-Journal.* "Just winning it made you feel so good because so many sportswriters had said we weren't a strong team."

JoJo had only one semester of eligibility left heading into the 1969 season. Owens could have held him out during the first semester and used him only during the second semester, but that made no sense because of the way school terms broke in those days. The Jayhawks had eighteen games scheduled during the first semester and only eight in the second semester. In his last game on February 1, he scored a career-high thirty points in front of

a sold-out crowd, which erupted with a thunderous roar as Owens removed him from the floor with twelve seconds left.

After graduating from KU in 1969 with a degree in physical education, White was a first-round draft pick of the Boston Celtics, where he spent ten seasons. He was such a dynamic and gifted all-around athlete that both the NFL Dallas Cowboys and the Cincinnati Reds also drafted him. A member of the All-NBA Rookie Team in 1969–70, White was later a seven-time All-Star and the Most Valuable Player in the 1976 playoffs when the Celtics defeated the Phoenix Suns for the NBA title. During his NBA career, White scored over 14,000 points, averaging 17.2 per game. In helping the Celtics to the playoffs six times, he averaged 21.5 points per game for eighty games.

He is perhaps most famous for his role in what many claim to be the "Greatest Game Ever Played"—the triple-overtime victory over the Phoenix Suns in game five of the 1976 NBA finals. He scored thirty-three points in over sixty minutes, catapulting the Celtics to its thirteenth NBA title and garnering him the Finals MVP award.

He was traded to the Golden State Warriors in 1979 and retired in 1981 with the Kansas City Kings. He returned to the Jayhawks as an assistant coach for the 1983 season. White has always placed a priority on education and learning. He now works for the Center for the Study of Sport in Society as director of a continuing education program for professional basketball players. The center is sponsored by the NBA to help athletes complete their college degrees. He has also operated the JoJo White Growth League, a program for middle school–aged kids that emphasizes the importance of education. "That's an important age," White said. "I think back to the values that were instilled in me by my parents, right on through the community and school. They became more important than all I had achieved on the court."

One of the greatest players in Celtics history, White had his number ten jersey retired by the Boston Celtics in a ceremony at Boston Garden on April 9, 1982. He remains in the Celtic organization as director of special projects and community relations representative.

On a personal note, I was pursuing a graduate degree in business while JoJo was at KU, and while we didn't have any classes together, I did have the opportunity to occasionally see him in Summerfield Hall. While KU has had its share of great guards over the years, perhaps I'm biased, but I still rate him as the best of all time.

# THE 1970S

E ven with the departure of JoJo White, the early 1970s saw considerable success for the Jayhawks, with Dave Robisch and Bud Stallworth forming the country's best frontline in 1971. That season, the Jayhawkers stormed through the Big Eight with a perfect 14-0 record and finished the regular season 25-1, the best in school history. After beating Houston and Drake in the NCAA tourney, KU lost a heart breaker to eventual champion UCLA in the Final Four.

The Jayhawks had two losing seasons after Robisch's departure. But in one of the more dramatic turnarounds in college basketball history, the Jayhawks bounced back from an 8-18 record in 1972–73 to become one of the top teams in the nation. The '74 Jayhawks battled all the way to the Final Four, completing a 23-7 record, becoming the first team in twenty-three years to come off a losing season and charge to the NCAA finals.

In 1978, after several mediocre seasons, freshman Darnell Valentine led KU to its sixth conference title under Ted Owens. Along the way, on December 7, 1977, Kansas lost to Kentucky in Allen Field House. Ironically, earlier that day, former Kentucky coach and KU Legend Adolph Rupp had passed away. And at the end of the season, the Jayhawks lost again in the NCAA tourney to eventual champion UCLA, 83–76.

## DAVE ROBISCH (PLAYER: 1969–71)

David George Robisch was born on December 22, 1949, in Cincinnati, Ohio, and played his first year of high school basketball there, but he finished his prep career in Springfield, Illinois, where he starred on the court.

Robisch, a six-foot-ten left-hander with a knack for banking the ball in the basket, led KU in scoring each of his three varsity seasons. As a sophomore in 1969, he averaged 18.1 points per game, leading KU to the NIT. His junior year, he averaged 26.5 points a game, tops in the Big Eight, on his way to Big Eight Player of the Year. As a senior, he averaged 19.2 points, leading

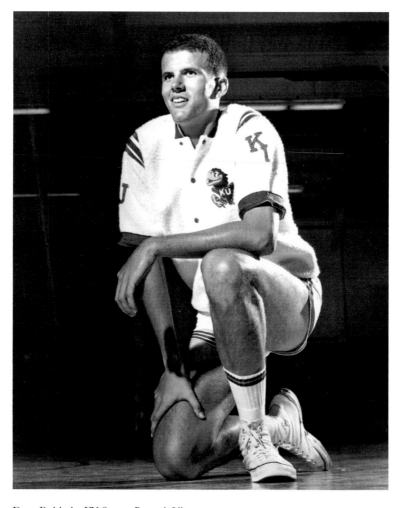

Dave Robisch. *KU Spencer Research Library.*

undefeated KU to the 1971 conference title and to the Final Four, where KU lost to eventual champion UCLA.

Robisch said, "The one shot I remember the most was the one I made to put us ahead in the second half against UCLA, but they called me for traveling." Most viewers thought that the Bruins received a kind whistle on the phantom traveling call, stopping KU's momentum.

He finished with 1,754 career points (ending as KU's second all-time scorer and now ranks ninth) and 815 rebounds (now twelfth best by a Jayhawk).

He also lettered two years as a baseball pitcher and was all-conference in 1969. Courted by pro-baseball scouts, Dave chose basketball instead and was selected in the fifth round by the ABA Denver Rockets. After three years in Denver, he became part of one of the most infamous trades in ABA history. The Baltimore Claws had obtained the rights to star Dan Issel from the Kentucky Colonels. The Claws were unable to come up with the $500,000 they owed the Colonels, so they traded Issel to the Nuggets in exchange for Robisch and $500,000, using the cash to pay the Colonels.

Shortly after arriving in Baltimore, the Claws folded. Robisch then became the victim of circumstance and was moved to four other teams in a five-week span, finally landing with the Indiana Pacers of the NBA, where he stayed three seasons. In 1979, he was traded to the Cleveland Cavaliers, then back to the Nuggets and finished his career with the Kansas City Kings in 1984. In thirteen seasons, he played in 930 games, scoring 10,581 points and making 6,173 rebounds.

Robisch had his jersey number forty placed on the Allen Field House south wall on February 27, 2005. In 2008, he was inducted into the Kansas Sports Hall of Fame. After retiring from the Illinois Department of Human Services, Robisch is currently an elected official in his native Springfield, Illinois, serving as a trustee of Capital Township.

## BUD STALLWORTH (PLAYER: 1970–72)

Isaac "Bud" Stallworth Jr. sent the fans into a frenzy when he hit for fifty points in his final collegiate game on February 26, 1972, a 93–80 victory over archrival Missouri, setting a school single conference game record that still stands today. Clyde Lovellette, on hand for the twentieth reunion of KU's 1952 NCAA champions, watched Bud surpass his own personal high of forty-four with 6:16 remaining in the game. In fact, the fifty points were the second-highest

Bud Stallworth. *KU Spencer Research Library.*

output by a KU player in school history, behind only Wilt Chamberlain's fifty-two points against Northwestern in 1956. "It was my last game here, and my mother got to see me play for the first time," Stallworth said

The story of Stallworth's discovery is now burned into the pages of KU basketball history. His discovery by Coach Ted Owens was almost by accident, as his journey to KU did not begin on the basketball court but

rather in music class in his segregated Alabama school. His father was the principal of Morgan County High, the all-black school he grew up in, and his mother was a teacher there. In the Stallworth household, education and the arts held precedent over athletics. His parents agreed to let him play basketball as long as he kept an A average and participated in the band. At age sixteen, between his junior and senior years of high school, he earned a scholarship to attend the KU Midwestern Music & Art Camp. His sister Harrietta, a math major at KU, had urged Bud to come to gain some trumpeting experience.

During lunch breaks at the camp, Stallworth would put down his trumpet, pack up his Converse shoes and run over to play basketball at nearby Robinson Gymnasium, where KU basketball players were playing pickup games. Although skinny, he held his own against the likes of All-American JoJo White. JoJo felt that Bud had a chance to become something special and emphatically told Owens, "You've got to see this guy."

Stallworth recalled:

> *I get back to my dorm; my counselor calls me. He said this guy named Ted Owens was looking for me. I gave Coach Owens a call, and he told me that several of his players thought I was pretty good. I didn't know where this was going, but he just cut to the chase and said, "We're very serious about this. If we can convince your parents and get their permission, we would like to give you a full scholarship to KU for basketball."*

Stallworth had been the first black player the University of Alabama attempted to recruit, but in contrast to his experience of playing pickup basketball with KU students, Stallworth said he never met the team on his recruiting trip to Alabama. "Neither Alabama nor Auburn's basketball programs compared to KU's rich history and national prominence, so I chose the Jayhawks and never regretted the decision."

As a frosh, he led the KU freshman team in scoring and rebounding. Because athletes were not allowed to participate in varsity athletics as freshmen, Stallworth did not see varsity action until the 1970 season. He wasted no time in asserting himself as a dominant player by scoring twenty-seven points in the season opener. The season ended 17-9 overall, second in the conference, and Stallworth was the team's third leading scorer and rebounder.

Stallworth played a key role on the 1971 team, the only team in Kansas history to go unbeaten in conference play and win its conference

tournament. Bud was the shooting guard on one of the biggest and most physical teams in the nation. A fearless shooter, he would be much higher than eighteenth on KU's all-time career list if the three-point shot had been in existence and if he hadn't played in an era when freshmen were excluded from varsity competition.

The Jayhawks entered the Final Four in Houston at 27-1, losing only to Louisville earlier in the year. Although the Jayhawks were down thirteen points with less than five minutes to go against the talented UCLA Bruins, they put on a full-court press and tied it up late in the game. Center Dave Robisch scored, but the basket was negated on a controversial traveling call, and Roger Brown was called for goal tending, eliminating another score. KU wound up being another victim of UCLA's string of national titles, losing 60–68 in the semifinal.

During his senior year in 1972, four of the top six players from 1971 were gone, so Bud carried the load, averaging 27.9 points per game in conference play. Although the team finished with an 11-15 record, Stallworth was named an All-American. He has said that his proudest achievement was being one of only three Kansas players to earn All-American honors on the court and in the classroom.

> *There's no amount of money in the world that they can pay you to make you feel good as you do when you run into Allen Field House as a basketball player. There's nothing like it. I played five years in the NBA and I never ran on the court feeling the way I felt running on the Allen Field House court.*
> —Tales from the Jayhawk Hardwood

Bud was drafted as the seventh pick in the first round of the 1972 NBA draft by the Seattle Supersonics and later played for the New Orleans Jazz. His career was tragically cut short in 1977, when a cab he shared with some teammates ran a red light and broadsided another vehicle. The accident left him with a herniated disc in his lower back and forced him to retire. In 313 games over his five-season pro career, he averaged 7.7 points per game. He went back to KU and graduated with a bachelor's of social work in 1978.

After a stint as a restaurant owner in Hawaii, Stallworth returned to Kansas in 1987 to serve as director of design and construction at the KU Medical Center and then moved to Lawrence to serve in KU's Design and Construction Management Department. He was in charge of 1996's $40 million Crumbling Classroom initiative, providing improvements to more than sixty campus buildings, and then worked on the construction of the

Lawrence Journal-World *photograph by Mike Yoder.*

KU Athletic Hall of Fame. He's an avid golfer and loves riding horses at his 160-acre ranch on the outskirts of Jefferson County.

Stallworth's number fifteen jersey hangs in the Allen Field House, having been appropriately retired at the KU-MU game in Lawrence on January 31, 2005. "When you join the KU Legends in the rafters, you become part of history. I'm honored to have been a part of this program and university close to 30 years. It's made me one of the luckiest people in the world."

He has been very active in numerous charity organizations, which he says has become his "passion." He has served on the board of directors for Kansas Special Olympics, on the advisory board for KU's School of Social Welfare and with a program for racial diversity and harmony called Celebration of Cultures.

Former coach Ted Owens said that although Stallworth would always be remembered as a KU Legend, he was more proud of Stallworth's charity work and the man he has become. As evidence that he is still remembered, even now when he walks out on the floor of Allen Field House, the band breaks out in the Budweiser song, and the fans sing: "When you say Bud, you've said it all."

## DARNELL VALENTINE (PLAYER: 1978–81)

Darnell Terrell Valentine was born in Chicago, Illinois, but grew up in Wichita, Kansas. In 1977, he was named the first McDonald's All-American from Wichita, Kansas, where he played for a Wichita Heights team that many consider the best prep team in Kansas history. He averaged twenty-six points for a 23-0 Heights team that had a winning margin of forty points a game and clinched the state championship.

He was one of the first Kansas high school players to be recruited nationwide. The Jayhawks won his services after a spirited recruiting battle with North Carolina's Dean Smith. Tipping the scales in KU's favor, perhaps, was the fact that Jayhawk coach Ted Owens hired Lafayette Norwood, Valentine's high school coach, to be an assistant.

The six-foot-one guard Valentine had a brilliant career at Kansas, becoming the first player in Big Eight history to be selected first team all-conference four times. He led the Jayhawks to the 1978 Big Eight title as a freshman and to two appearances in the NCAA tournament and was selected to the 1980 U.S. Olympic basketball team but didn't participate as

Darnell Valentine. *KU Spencer Research Library.*

the United States boycotted the Moscow Games. Valentine left KU as the school's leader in career steals and free throws and as the second-leading scorer in KU history, behind Clyde Lovellette; he was also named Academic All-American three times.

Darnell was drafted in the first round (sixteenth pick overall) by the NBA's Portland Trailblazers in 1981. He spent four and a half years in a Blazers uniform. Darnell also played for the LA Clippers and the Cleveland Cavaliers during his ten-year NBA career. He owns career averages of 8.7 points per game, 2.1 rebounds per game and 5.0 assists per game in 620 NBA contests. After completing his NBA career, Darnell played three seasons in the Italian Basketball League.

Former Portland Trailblazers coach Jack Ramsey said:

> *Darnell Valentine was perhaps the most self-disciplined player I ever dealt with. DV—who had watermelon-sized quads, a strong upper body and excellent quickness handling the ball and defending—worked fanatically on his conditioning. In addition to his fierce work ethic, relentless self-discipline and powerful will to win, he always wore a smile and was one of the best team players I ever coached.*

For ten years, Valentine served as a regional representative for the National Basketball Players Association. He helped facilitate NBPA player development meetings, worked on the NBA All-Star Game players' meetings and the NBA players' annual summer meeting. Valentine also participated in the Top 100 High School Players' Camp sponsored by the NBPA.

Darnell was inducted into the Kansas Sports Hall of Fame in 2003, and his KU jersey number was retired on January 2, 2005, at halftime during KU's game with Georgia Tech. "This is the crowning moment for me. I can certainly appreciate this and relish the fact that it's happening now," said Valentine. He currently works in Portland, Oregon.

# DANNY AND THE MIRACLES

After Darnell Valentine left, KU experienced two losing seasons, leading to the firing of Ted Owens after the 1983 year. Owens, however, did not leave the cupboard bare for new coach Larry Brown. In 1984, Brown used Owens's recruits to lead KU to a 22-10 overall record and a 9-5 mark in the conference as KU won the postseason Big Eight Tournament and made it to the second round of the NCAA tournament.

In 1985, he brought in Danny Manning (along with Danny's father, Ed, as an assistant). They finished 26-8, losing to Auburn in the second round of the NCAA tourney. With one of the best teams in KU's history, the 1986 team won the Big Eight title and eventually lost to number one Duke in the Final Four, finishing the season 35-4. After an OK season, at 25-11, in 1987, many thought Manning would not return for his senior year.

He did, of course, but 1988 turned out to be a season of heartbreak, adversity and triumph. After being a pre-season number one pick, the Jayhawks stumbled to a 12-8 start as starting forward Archie Marshall's career ended with a broken leg and starting center Marvin Branch was declared academically ineligible. They finished the regular season 21-11 but entered the NCAAs with Kevin Pritchard straining a knee in the Big Eight tournament and Otis Livingston and freshman Mike Masucci both suspended from the team.

With wins over Xavier, Murray State and Vanderbilt, the sixth-seed Jayhawks then beat Kansas State, avenging the losses to the Wildcats earlier in the season and earning a trip to the Final Four. Then they were scheduled

to play the number-five-ranked Duke Blue Devils, who had beaten the Jayhawks in the '86 NCAA semifinal and the current team, 74–70, in overtime a month earlier in Lawrence. KU got revenge again, with a 66–59 win, setting up an all–Big Eight final with Oklahoma, which had whipped the Hawks twice earlier that season.

In the historic championship game, the Jayhawks ran with the vaunted Sooners, tying the game 50–50 at the half. After seesawing throughout the second half, the Jayhawks finally prevailed, 83–79. In the end, the Jayhawks won because of the earlier heartbreaks and adversity that brought them together as a team at the right time.

Brown was able to lead KU to great success during his five-year stint because he was able to attract considerable talent to his coaching staff, including Greg Popovich, who has since coached the San Antonio Spurs to three NBA championships; R.C. Buford, the current general manager of the Spurs; Kentucky head coach John Calipari and his assistant, John Robic, who took the Memphis Tigers to the NCAA title game against KU in 2008; Mark Turgeon, the present head coach of the Maryland Terrapins; Alvin Gentry, who was head coach of the Phoenix Suns; Bill Bayno, currently an assistant coach for the Minnesota Timberwolves; and even Bill Self, KU's current head coach, who served as a graduate assistant in 1986.

During Brown's five-year stint, this outstanding bunch directed KU to a total of 135 wins in 179 games, a 75.4 percent winning record, including, of course, the NCAA national championship in 1988.

## LARRY BROWN (COACH: 1984–88)

Lawrence Harvey "Larry" Brown was born in Brooklyn, New York, and attended Long Beach High School. After high school, he played at the University of North Carolina under Frank Maguire and Dean Smith, where he averaged 11.8 points per game. The five-foot-nine, 160-pound Brown captained the Tarheel basketball team as a senior in 1963.

### *Professional Playing Career*

Brown was considered too small to play in the NBA, so he began his professional career with the NABL's Akron Wingfoots, where he played for two years.

During that time, Brown was selected for the 1964 Summer Olympics team while leading the Wingfoots to the 1964 AAU National Championship.

Then Brown served as an assistant coach at North Carolina for two years: "Coach (Dean) Smith gave me my first coaching job. I made $6,000 and I had to run the summer camp. I thought I was overpaid."

Brown joined the New Orleans Bucs of the new American Basketball League in 1968 and was named MVP of the ABA's first All-Star Game. He went to the Oakland Oaks in 1969 and helped lead them to the 1968–69 championship, leading the league in assists. Subsequently, he played for the Washington Caps in 1970, the Virginia Squires in 1971 and the Denver Rockets in 1972.

Brown led the ABA in assists per game during the league's first three seasons, and when he ended his playing career, Brown was the ABA's all-time assist leader. His total of 2,509 assists places him seventh on the ABA's career list, and he holds the ABA record for assists in a game, with 23. As player and coach, Brown was a part of the ABA for all nine seasons of the league's existence.

## *Coaching*

Brown returned to coaching in 1972. His first head-coaching job was at Davidson College in North Carolina. Unfortunately for Wildcats fans, it would last only during the summer offseason, and he never coached a game. That one-month experience would be a harbinger to Brown's nomadic coaching career.

He signed with the ABA's Carolina Cougars, and was named Coach of the Year his first of two seasons at the helm, and then with the Denver Rockets in 1976. But that marked the final season for the ABA. Nonetheless, he continued to coach the Denver franchise when it joined the NBA as the Nuggets for the 1976–77 season, winning two division titles in three seasons.

After resigning as the Denver coach, he then moved on to coach UCLA for two seasons, leading his freshman-dominated 1980 team to the NCAA title game before falling to Louisville, 59–54. The following year, his third-ranked UCLA team again qualified for the NCAA tournament but enjoyed less success, prompting him to resign.

Later that year, Brown was back coaching in the NBA, taking over the head-coaching job of the New Jersey Nets. The Nets were the Eastern Division's last-place team before Brown took the reins, but he led them to

Brown and Manning. Lawrence Journal-World *photograph by Mike Yoder.*

the playoffs in his first full season, as well as the following year. Under Brown, the Nets were 91-69 from 1981 to 1983.

But the following season, he accepted the top coaching job at the University of Kansas. KU finished second in the Big Eight in 1984 and

1985 and first in 1986 and 1987. In 1988, due to injuries, Kansas got off to a mediocre 12-8 start, including 1-4 in the Big Eight, and the end of the Jayhawks' fifty-five-game home court winning streak in Allen Field House. Ultimately, behind the high-scoring Danny Manning, KU finished 27-11 and won the national championship in 1988, defeating favored conference rival Oklahoma, 83–79, in the final. During his tenure at Kansas, Brown led the Jayhawks to five NCAA tournament appearances, three Sweet Sixteen appearances and two trips to the Final Four. He was named Big Eight Coach of the Year in 1986 and national Coach of the Year in 1988.

In five seasons at KU, Brown had a 135-44 (.754) record. The stint was the shortest for any Jayhawks coach in history, but for Brown, it may have seemed like an eternity. He had a reputation in coaching for not sticking around, but he spent more time in Lawrence than he had in any other place. However, he left under a cloud, as NCAA sanctions were levied against Kansas in the 1989 season as a result of recruiting violations that took place during Brown's tenure. Kansas was banned from the 1989 NCAA Tournament—the only time a defending champion has been banned from defending its title.

So Brown decided to return to the NBA, and from 1988 to 1992, he coached the San Antonio Spurs to the playoffs his last two full seasons there. Nonetheless, midway during the 1992 season, he left the Spurs and took over the top coaching spot with the Los Angeles Clippers.

The Brown-directed Clippers finished the NBA season with twenty-three wins and twelve losses and did something the franchise hadn't done for years—made the playoffs. The following season, the LA team made the playoffs again, this time with a 41-41 win-loss record. However, at season's end, with two years left on his contract, Brown resigned as Clippers coach. He has since led the Indiana Pacers, Philadelphia 76ers (where he won the NBA coach of the year award), Detroit Pistons and New York Knicks. He won his first NBA championship during his first year with the Detroit Pistons in 2004, defeating the Los Angeles Lakers four games to one in the NBA finals. By doing so, Brown became the first man to coach teams to both NCAA and NBA titles.

During his Pistons period, Brown accepted the position of head coach of the 2004 USA Men's Olympic basketball squad. At the Athens Games, however, his "dream team" managed only a disappointing bronze medal. No one else has been both a player and head coach of the U.S. Olympic basketball team.

On April 29, 2008, Brown signed to become the head coach of the Charlotte Bobcats—his ninth NBA coaching job. He managed to keep the

relatively young team in playoff contention well into March and led the Bobcats to their first post-season playoff appearance the next season. He left Charlotte in the middle of the next season.

On April 17, 2012, Brown was named the head coach of the Southern Methodist University Mustangs.

Though he has received criticism for never staying in one place for very long, Brown is hailed as one of basketball's greatest teachers and is well known for turning losers into winners. Brown has led his teams to seventeen playoff appearances, eight fifty-win seasons, seven division titles, three conference championships and one NBA championship with the Detroit Pistons in 2003–04. Brown was enshrined in the Naismith Memorial Basketball Hall of Fame as a coach on September 27, 2002.

## DANNY MANNING
## (PLAYER: 1985–88; DIRECTOR OF STUDENT OPERATIONS: 2003–07; ASSISTANT: 2007–12)

With all due respect to the talent of Wilt, Danny Manning was the greatest overall player in the history of the storied University of Kansas basketball program, evidenced by the facts that he is Kansas's all-time leading scorer, with 2,951 points, and rebounder, with 1,187.

Danny was born on May 17, 1966, in Hattiesburg, Mississippi. His father, Ed, was a former NBA professional basketball player. In the early '80s, they lived in Greensboro, North Carolina, where Danny starred on the Page High School team, drawing attention from recruiters across the country. The Mannings moved to Lawrence in 1983, when new KU coach Larry Brown hired Ed as an assistant. Manning had been a former teammate of Brown in the ABA and had been working as an over-the-road trucker.

And so Danny spent his senior year at Lawrence High School, and what a year it was. LHS officials were astonished at the crowds who came to watch the star, who had committed to KU. Leading the Lions to the 6A state championship game, where they lost a heartbreaker to Wyandotte High, he was named the 1984 Kansas Player of the Year.

## *At Kansas*

Danny was immediately installed in the Jayhawks' starting lineup, scoring a KU freshman record of 496 points during the 1985 season and being named the Big Eight Newcomer of the Year and second team all-conference. "Danny was obviously a fabulous player," said Bill Self, a senior at Oklahoma State that year. "I saw first-hand having an opportunity to play against him when I played the back of a 2-3 zone at Oklahoma State and he went 15-of-16 from the field against us. Then I had the opportunity to towel him off and fetch water for him as a graduate assistant his sophomore year."

As a sophomore, Danny had a pivotal role on KU's Final Four team, leading the Jayhawks in scoring, while capturing the Big Eight's Player of the Year award and earning second team All-American honors.

As a junior, Manning became the sixth Jayhawk to earn consensus first team All-American honors, while averaging 23.9 points and 9.5 rebounds per game. He became the all-time leading scorer in Kansas history when he scored 31 points against Missouri during the Big Eight tournament. He was named the conference Player of the Year for the second year.

Although the decision was difficult, as he was likely a very high prospect in the upcoming NBA draft, Manning chose to forego the draft and return for his senior season. It was a strange year. With ten players returning, the Hawks were named number one in many of the preseason polls, but a career-ending injury to starting forward Archie Marshall and losing starting center Marvin Branch caused the team to falter to a 12-8 start. Then things started to gel, as they won their next five conference games, before falling to number six Duke and number four Oklahoma. They then won four of the next five games, to end the regular season at 21-11.

Now unranked, KU got a number six seed but beat number eighteen Xavier, squeaked by fifteenth-seed Murray State and then beat Vanderbilt to reach the Elite Eight, where it was joined by Big Eight foes K-State and Oklahoma, both of which had beaten KU twice earlier in the season. KU turned the game against the Wildcats into a runaway 71–58 victory. Revenge was again on the Jayhawks' minds, as they were scheduled to play the number-five-ranked Duke Blue Devils, who had beaten the Jayhawks in the '86 NCAA semifinal and the current team 74–70 in overtime a month earlier in Lawrence.

In a seesaw game against the Blue Devils, which was close with four minutes to go, Manning stuffed in a missed layup, rebounded, blocked shots and led the avenged Jayhawks to a 66–59 win, to set up the first all–Big Eight championship game in NCAA history.

Every scouting report said "don't run with Oklahoma." But the Jayhawks did run and made seventeen of their first twenty field goal shots, ending the half with 71 percent from the field. The half ended in a 50–50 tie against the fourth-ranked Sooners. They had played OU's game and survived. Coach Brown had substituted freely, while Tubbs had rested only one starter for three minutes.

In the second half, the game seesawed with KU finally going ahead 77–71 with three minutes to go. However, KU missed four of its next five free throws while Oklahoma came back to within one, 78–77. Then Scooter Barry put in a free throw, and Manning drew a foul at 0:14. He made both, and another two after being fouled with five seconds left, to salt away the national championship. Not only was Manning named the Most Outstanding Player of the 1988 NCAA tournament, but he was also named the national Player of the Year.

## 1988 Olympics

Danny was selected on the last Olympic basketball team made up of collegians. Unfortunately coached by Georgetown's John Thompson, who incredibly benched Manning in a crucial game, which put the United States out of the gold medal running, the team wound up with the bronze.

## In the Pros

It's difficult for today's youth to imagine just how wonderful a player Manning was because they're programmed to measure a basketball player by his NBA stature. Manning was never the player in the pros he was in college because he suffered three ACL injuries—the first during his rookie season with the Los Angeles Clippers, which had selected him with the first pick in the 1988 NBA draft.

When Manning suffered that first knee injury, after playing only twenty-six games in the NBA, Kansas fans were stunned. They were convinced Manning was indestructible. During his four years at Kansas, Manning hadn't missed a single game because of an injury while playing virtually every minute.

The next year didn't start well either, as he missed the first eleven games with a knee injury. However, he ended up playing seventy-one games and

finishing third on the team in scoring. He also missed nine games in 1991 with knee problems.

His health returned, however, and he started all eighty-two games in 1992, averaging 19.3 points, 6.9 rebounds and 3.5 assists. His most productive NBA season was 1992–93, when he averaged 22.8 points a game and was selected to play in the All-Star game. He was also an All-Star the following season.

Late in the 1994 season, he was traded to the Atlantic Hawks, leaving Los Angeles as the Clippers' all-time leading scorer, with 7,120 career points. In 1995, after being traded to the Phoenix Suns, he again tore his anterior cruciate ligament in his left knee and was lost for the season.

Continuing knee problems forced Manning to become a part-time player in 1996, after he had undergone two more surgeries. He won the 1997–98 Sixth Man Award as the best off the bench in the NBA, averaging 13.5 points, though he played only about seventeen minutes a game.

Manning went to the Milwaukee Bucks in 1999 and played for different teams during his final four seasons in the league. He announced his retirement in the summer of 2003.

## *Back to KU*

New Jayhawk coach Bill Self hired Manning to be the director of student-athlete development/team manager at KU. In that position, Manning was the team travel coordinator, oversaw equipment ordering and distribution and organized and assisted in the youth holiday clinic and summer camp program. In 2004–05, Manning also took on many director of operations duties for KU.

In March 2007, Danny was promoted to assistant coach. Self said, "I mean, who wouldn't want their son to be mentored by a guy who has everything you want your son to be? Think about it: he graduated, won a national championship, was No. 1 pick in the draft, an Olympian, two-time NBA all-star, family man, has his priorities straight. Who wouldn't want their son mentored by a guy like that on a daily basis?" In his role as assistant coach, Manning worked with KU's big men. Eight Jayhawk bigs were selected in the NBA draft while he was on staff.

On April 4, 2012, Manning was officially announced as Tulsa University's head coach. He and his wife, Julie, have a daughter, Taylor, and a son, Evan.

## Latest Honors

- Jersey retired during the 1992 season.
- Voted to the all-time All–Big Eight basketball team in 1996.
- Enshrined in the National Collegiate Basketball Hall of Fame on Sunday, November 23, 2008.
- Named to the Guilford County Sports Hall of Fame for his early high school career at Page High School in North Carolina.
- Member of the Lawrence (Kansas) High School Hall of Fame.

## KEVIN PRITCHARD (PLAYER: 1987–90)

*Kevin was never a natural point guard, but he made himself into one. He had great confidence and was a great competitor. Because of that, he succeeded to a level many people probably never would have dreamed.*
—*R.C. Buford, then an assistant on Brown's Kansas staff and now general manager of the San Antonio Spurs.*

## KU Career

After being named a McDonald's All-American selection at Tulsa's Edison High School in 1986, Kevin Pritchard committed to Larry Brown's Kansas Jayhawks. When he arrived at KU as a freshman in 1986, he was a six-foot-three guy with average quickness, a decent jump shot and a boatload of determination. "During the time we recruited Kevin, he told us he wanted to play point guard," said Larry Brown, then the Kansas coach. "I told him he wasn't a point guard, that hopefully after being at Kansas awhile he could develop into one, but I couldn't promise him he'd be our point."

Seven games into his college career, Pritchard became Kansas's starting shooting guard. The next season, he moved to point guard and led the Jayhawks to the 1988 NCAA championship, averaging 10.6 points per game. The 1989 season was a down year for the Hawks, which, in addition to losing four starters from the 1988 squad, had been put on probation by the NCAA because of some relatively minor recruiting infractions and, as a

Kevin Pritchard. *KU Spencer Research Library.*

result, were severely limited in recruiting. With new coach Roy Williams, the Jayhawks compiled a 19-12 record.

However, the Jayhawks came back strong in 1990, led by senior Pritchard to a 30-5 record and the NCAA regionals. Pritchard averaged in double figures his final three seasons and was an all–Big Eight

selection as a senior. Even more notably, he was a three-time all–Big Eight Academic Team selection.

## Professional Career

Following his distinguished college career, he was chosen in the second round of the 1990 NBA draft by the Golden State Warriors. He played ninety-four games during his four years in the NBA, making stops at Golden State, San Antonio, Boston, Miami, Philadelphia and Vancouver. He then played three years in Europe before retiring as a player in 1997.

## Coaching and Management Career

After a year working as a mutual funds manager and investment analyst, Pritchard became head coach and general manager of the Kansas City Knights of the ABA for two successful seasons, leading them to a league championship in 2002. Later, he was hired to be a scout for the San Antonio Spurs and two years later was hired as director of player personnel by the Portland TrailBlazers. In 2005, the Blazers named Pritchard as interim head coach, replacing the fired Maurice Cheeks.

He was promoted to assistant general manager in 2006 and was involved with making several significant trades that were considered to be very favorable for the Blazers. In March 2007, he was named the team's general manager and has since orchestrated more trades of significance. "I've worked my way up from the bottom. I feel like all my experiences up to now have prepared me for what I need to do to become a good GM," says Pritchard. Due to his track record of one-sided trades benefiting the TrailBlazers, some sports commentators have coined the phrase "pritch-slap" in honor of Pritchard's alleged managerial acumen.

Pritchard was relieved of his general manager duties on June 24, 2010. About one hour before the 2010 NBA Draft, Kevin Pritchard was notified by owner Paul Allen that he had been fired, but Allen wanted to make it clear that he needed to stay for the draft. Pritchard made a trade and two draft selections, which satisfied TrailBlazer team officials.

Pritchard is currently director of player personnel for the Indiana Pacers.

# ROY WILLIAMS'S TENURE

The celebrations of the 1988 National Championship ended, if not with Larry Brown's departure to the NBA, then certainly with KU being slapped with a three-year probation stemming from rules violations. Mainly, Brown had purchased an airline ticket for a recruit, Vincent Askew, to visit his dying grandmother. The school lost three scholarships for the next year, couldn't bring recruits to campus for a year and could not defend its national title, being banned from post-season play for a year. The way the Jayhawks were treated, you would think they were UNLV!

Newly hired coach Roy Williams was stunned. However, his 1989 team went 19-12. Unexpectedly, the 1990 team rebounded with a 30-5 record and lost to UCLA in the second round of the NCAA tourney, the fourth time the Bruins had beaten the Jayhawks in NCAA play. Then, the surprising '91 team almost won it all. On their way to the championship game, the Hawks beat New Orleans, Pittsburgh and Indiana before toppling number one Arkansas to earn a place in the Final Four.

Then Kansas beat North Carolina, Williams's alma mater, in the national semifinals, 79–73. But Duke, behind Christian Laettner, Grant Hill and Bobby Hurley, beat Kansas in the finals, ending a memorable run.

That began a fantastic run of seven years, when KU won at least twenty-five games per year from 1992 through 1998. In 1993, KU lost to North Carolina in the Final Four and won at least two games in the NCAA tournaments the next four years. However, in 1998, number one KU stumbled, losing to lowly Rhode Island in the second game.

The next three years were just OK by KU standards, with no conference titles and short stays in the NCAA tournament. In 2002, however, the Jayhawks finished the regular season 29-3, first place in the conference, and entered the NCAA as a number one seed. Even though Kirk Hinrich had a sprained ankle, KU won the next three games, avenging the previous year's loss to Illinois. KU then routed Oregon 104–86, before losing to a relentless Maryland team in the Final Four.

The next year, the 2003 team made an incredible run all the way to the championship game. In spite of losing Wayne Simien, who played in only sixteen of KU's thirty-eight games, the Jayhawks finished the year ranked first in the country in scoring margin (+15.8), second in rebound margin (+7.9) and third in scoring offense (82.7). Unfortunately, missed free throws in the championship game with Syracuse cost the Jayhawks the title.

After the year, Roy returned to his alma mater, North Carolina, and a week later KU introduced Bill Self as the eighth head coach in KU's basketball history.

In fifteen seasons in Lawrence, Williams's teams won an amazing 418 games, with only 101 losses, an 80.5 percent winning record, going down as one of KU's greatest coaches.

## ROY WILLIAMS (COACH: 1989–2003)

*Williams is straighter than an Arrow shirt, so square that he's divisible by four, and cornier than a corncob pipe.*
—*William Mack,* Sports Illustrated, *March 10, 1997*

## *Early Life*

Roy was born on August 1, 1950, and grew up in Biltmore, North Carolina, south of Asheville. His father was an abusive alcoholic who created a chaotic home. In his biography, Roy reported that

*one of our neighbors had a basketball goal in the backyard. I never had a basketball, but they had one, and when I wanted to get away from what was going on at home, I would just go over there and shoot. The goal was a*

*pole with a plywood backboard, and there was no net, just a bent rim. I'd go over there for hours. If it was raining or snowing, I'd get filthy on the dirt court, but I didn't mind. It was something I could do by myself.*

Later, he would go over to the gymnasium at Biltmore Elementary School and spend countless hours there shooting baskets. He was alone much of the time, and the game of basketball fit with his solitude. "I loved it more because I could do it when I was alone," Williams said. "Give me a ball and a goal and I was in heaven. It was my refuge, and there were no problems in the world."

Eventually his mother, Lallage, divorced and then eked by to provide for Roy and his older sister, Frances. Later, they relocated to nearby Asheville, where Williams attended T.C. Robertson High School. He lettered in baseball and basketball all four years. Playing basketball for Coach Buddy Baldwin, Roy was named all-county and all-conference in 1967 and 1968, all-region in 1968 and served as captain in the North Carolina Blue-White All-Star Game.

Williams has stated that Coach Baldwin was one of the biggest influences in his life. Baldwin became the father figure that he lacked and gave him a sense of purpose and belief in himself that he had never had before. At Baldwin's prodding, Roy had decided by the time he was a high school senior that he wanted to be a coach.

## North Carolina

Roy enrolled at the University of North Carolina and played freshman basketball as a walk-on in 1968–69. Not having been good enough to make the varsity his sophomore year, he played on the junior varsity team.

He financed his college education by patching together enough in loans and grants and began working four nights a week as an intramural softball umpire. He later became an intramural official for other sports and then the supervisor of officials. He kept stats for Coach Dean Smith at home games and, with Smith's permission, began in his sophomore year to attend practices as if they were academic lectures. Dreaming of eventually becoming a coach in Chapel Hill, he sat high in the bleachers, a lone and feverish scholar, scribbling notes on how Smith taught the game and orchestrated his clockwork practices.

Williams graduated from UNC in 1972 with a bachelor's degree in education and the next year received a master's of arts in teaching.

## High School Coaching

After getting married to Wanda, a North Carolina girl, he began his coaching career at Charles D. Owen High School in Swannanoa, North Carolina, about ten miles east of Asheville. He coached basketball and boys' golf for five years and ninth-grade football for four years and served as athletic director for two years.

Although his basketball record after five seasons was only 45-68, he turned his teams into an extended family and tried to instill in his players the same sense of self-worth that Baldwin had imparted to him.

## Back to Chapel Hill

Smith had employed Williams at his basketball camp for several summers, and when a position for a part-time assistant opened on his staff at North Carolina in 1978, Smith offered it to Roy. The job paid $2,700 a year. By then, the Williamses' had an infant son and a mortgage to pay on their new house, and they both had good jobs—Wanda was a high school English teacher—that would pay them a combined $30,000 a year. When Williams mentioned the offer to Wanda, she groaned in protest. "That's the dumbest idea I've heard of," she said.

But he and Wanda packed up the U-Haul and left the mountains of western Carolina to fulfill their dream. They scratched to survive, but Smith arranged a high school teaching job for Wanda, at $9,000 a year. After each season was over, Roy supplemented their income by selling Tarheel basketball calendars.

Williams honed his coaching skills as an assistant coach at North Carolina for ten years, learning under the winningest coach in college basketball history, Kansas legend Dean Smith. During his tenure as assistant coach, North Carolina went 275-61 and won the NCAA national championship in 1982. One of his more notable events as assistant coach came when he became instrumental in recruiting Michael Jordan.

## To Kansas

In April 1988, Danny Manning and the Miracles cut down the nets in Kansas City after beating Oklahoma 83–79 for the national title. But no sooner had

the cheering stopped than Larry Brown, the Jayhawks' coach, bolted for the San Antonio Spurs in the NBA, leaving behind an investigation of supposed impropriety by the NCAA.

At the urging of Dean Smith, Kansas athletic director Bob Frederick invited Roy to interview for the job. Roy and Wanda cut short a Bermuda vacation, the first they had taken in four years, to fly at once to Lawrence. Before the meeting was over, Frederick sensed that he had found his man and offered him the job.

Knowing that the KU faithful wanted a big-name coach, Frederick told Smith after meeting Williams, "I know I'll catch a lot of heat for this in Kansas." But Williams was unsure he was worthy. "Coach, are you sure that you think I can do this?" he asked Smith. With Smith's encouragement and blessing, he took the job.

The fall of 1988, he got verbal commitments from three highly regarded prospects. But then the axe fell as KU was hit hard by the NCAA for violations that occurred under Brown. The penalties were severe: no post-season play for a year and the loss of three scholarships and all paid campus recruiting visits for one year. That scared off two of the recruits, but Adonis Jordan agreed to stay.

Almost immediately upon Williams's arrival at Kansas University, the Jayhawks again became a feared and respected team in the world of Division I basketball. In fifteen seasons, from 1989 to 2003, his Jayhawk teams compiled an astonishing record of 418-101 (.805 winning percentage), ranking him first among all active coaches and third in the history of college basketball.

The Jayhawks went an incredible 201-17 (92.2 percent) in the cozy confines of Allen Field House, where they won sixty-two consecutive games in Allen from February 1994 to December 1998. Another remarkable record, one of solid consistency, was the Jayhawks' 94-18 (83.9 percent) record in Big Twelve conference play.

Under his reign, the Jayhawks averaged twenty-eight wins per season with a high of thirty-five in 1997–98. He also won thirty in 1989–90, thirty-four in 1996–97, thirty-three in 2001–02 and thirty in 2002–03. The Jayhawks reached the Sweet Sixteen nine times and the Final Eight on five occasions. Overall, Williams had Kansas in the AP Top 25 in 242 of 268 weekly polls. Kansas reached the number one ranking in the country in six different seasons and was ranked at least number two in the nation in eleven of the fifteen seasons.

Kansas went 30-8 in 2002–03, Williams's final year in Lawrence. Led by Nick Collison, the NABC National Player of the Year, and Kirk Hinrich,

an All-American, the Jayhawks reached the national championship game. It was KU's first back-to-back appearance in the Final Four since 1952–53.

Williams was faced with the opportunity to return to North Carolina in 2000, when Bill Guthridge left the head coaching position vacant. After national media sources prematurely announced Williams would take the position, they quickly backed off as it became clear that Williams's mind was not made up. North Carolina media continued to report that he had accepted the position. After a week of this back-and-forth, Williams held a press conference at Memorial Stadium, where he announced, "I'm staying at Kansas."

## Back to North Carolina

However, three years later, Williams ended up accepting the North Carolina head coaching position following the controversial three-year run of Matt Doherty, who had previously been an assistant under Williams at KU.

Williams helped coach Team USA to a bronze medal at the 2004 Summer Olympics in Athens, Greece, with former Kansas coach Larry Brown.

On April 4, 2005, Williams shed his title as the "most successful coach to never have won an NCAA ring" as his Tar Heels defeated the University of Illinois in the 2005 NCAA Championship game. He would again lead them to victory four years later, defeating the Michigan State Spartans in the 2009 NCAA Championship game.

## Honors

Williams earned National Coach of the Year honors three times at Kansas, in 1990 (Henry Iba Award), 1992 (Associated Press) and 1997 (Naismith COY) and was Big Eight/Big Twelve Coach of the Year seven times (1990, 1992, 1995, 1996, 1997, 2002 and 2003). He received the prestigious John R. Wooden Legends of Coaching Award in April 2003. He was also named Associated Press Coach of the Year at North Carolina in 2006 and named by *Forbes* as America's Best College Basketball Coach in February 2009.

In reflection of his body of work, Williams was elected to the Naismith Memorial Basketball Hall of Fame on April 1, 2007. At the ceremony, Michael Jordan said:

*His willingness to understand the athlete and get the best out of the athlete is what makes Roy a Hall of Famer. His patience, his knowledge for the game, his effort and diligence to understand the game and understand the player and how they can co-exist. To me, that's a Hall of Fame-type guy, someone who makes adjustments according to the personnel rather than forcing his way of thinking on a team or a player.*

In 2009, Algonquin Books published Williams's autobiography, *Hard Work: A Life On and Off the Court*, co-written by Tim Crothers.

## Paul Anthony Pierce (Player: 1996–98)

*He has lived up to the meaning of his nickname—the Truth—by staying true to himself.*

Paul certainly qualifies as a true KU Legend, given his success at Kansas and now that he has led the Boston Celtics to an NBA title.

Pierce was born on October 13, 1977, in Oakland, California, and starred in basketball at Inglewood High School in Los Angeles.

During Pierce's three-year stint at KU, the Jayhawks won an astounding 90 percent of its games, ninety-eight wins against only eleven losses; accumulated three Big Twelve titles; and finished with a 6-3 NCAA tournament record. He averaged 16.4 points and 6.3 rebounds per game, earned MVP honors in the Big Twelve Conference tournament in 1997 and 1998 and was named First Team All-American by the AP in 1998.

Paul Pierce. *KU Spencer Research Library.*

After his junior year, he entered the 1998 NBA draft and was selected tenth overall by the Boston Celtics. He quickly emerged as a top player in the Eastern Conference.

The 2008 season was magical for Pierce. Before the season started, he expressed great excitement at the Celtics' acquisitions of fellow All-Stars Kevin Garnett and Ray Allen, giving Boston a chance to contend for a championship. On May 18, 2008, Pierce recorded the second-highest point total in franchise history in playoff game seven with forty-one points against the Cleveland Cavaliers, as the Celtics advanced to the Eastern Conference Finals. In game one of the 2008 NBA Finals against the Los Angeles Lakers, Pierce was injured in the third quarter and was carried off the court in severe pain. However, he came back to the court later to spark the Celtics with fifteen points in the third quarter en route to a 98–88 victory. He was named the NBA Finals Most Valuable Player after the Celtics grabbed the championship by winning game six.

Pierce is a ten-time NBA All-Star. He has been the model of consistency for the Celtics, averaging over twenty-three points per game in ten seasons, racking up over twenty-two thousand career points in fourteen seasons. His scoring average as a Celtic ranks second only to Larry Bird—and even then, not by far. He is the Celtics' all-time three-point scorer and ranks third in free throws and fifth in defensive rebounds.

Pierce established the Truth Fund in May 2002 as a means to connect with disadvantaged children in the Greater Boston area and his hometown of Inglewood, California. The mission of the Truth Fund is to provide educational and life-enriching opportunities for underprivileged youth by offering resources and programs that foster safe and stable environments. He has also created the Paul Pierce Nike Skills Academy, an annual program for the top twenty high school players. The athletes have an opportunity to receive personal instruction from Pierce along with top high school and NBA coaches.

Pierce was traded to the Brooklyn Nets after the end of the 2012 season.

CHAPTER 11

# SUPREME COURT

## BILL SELF (COACH: 2004–PRESENT)

Usually, Legends are those whose careers are over and their records have stood the test of time. Given Bill Self's career accomplishments to date, including his record at KU and being named national Coach of the Year three times, he certainly qualifies already as a Jayhawk Legend.

Born in Okmulgee, Oklahoma, and raised in Edmund, where he starred on the Edmund Memorial High School team and was named Oklahoma High School Basketball Player of the year in 1981, Self played collegiate ball at Oklahoma State, where he was a four-year letterman from 1982 to 1985. He received a bachelor's degree in business and a master's degree in athletic administration at OSU.

After graduating, he worked at Larry Brown's summer basketball camp at KU. Self remembered, "It was for little money, but you'd hang out and get all your expenses for a week. We played pickup games at night and then go out after that." After hurting his knee in a pick-up game, Brown asked him if there was anything he could do. Self responded, saying, "Coach, there is one thing. You can hire me as a graduate assistant next year." Without hesitation, Brown replied, "You're hired."

A year later, Self dropped into Brown's office unannounced, and Brown made him a graduate assistant for the 1985–86 season, a year when the Jayhawks went 35-4 and advanced to the Final Four, where they lost to Duke 71–64. In his book, *At Home in the Phog*, Self said, "The year I was at

Kansas under Coach Brown probably convinced me to make a career out of coaching."

He then returned to Stillwater, joining coach Leonard Hamilton's OSU Cowboy staff as an assistant coach for four years and then staying on for another three years under head coach Eddie Sutton.

Self began his head-coaching career at Oral Roberts University, which had compiled a 5-22 record the year before. Faced with a rebuilding job, he managed only six wins his first year and increased them to ten the next. In his third season, he guided the team to an 18-9 record, followed by a 21-7 record in 1996–97, and received an invitation to the NIT, ORU's first tourney appearance since the 1984 season. Self later reminisced, "Probably as much fun as a guy could have coaching was my time at Oral Roberts. I loved it. I learned how to coach at ORU."

Staying in Oklahoma, Self coached at cross-town rival Tulsa University from 1998 to 2000, when he led the Golden Hurricane to a record of 74-27 in three seasons, including trips to the NCAA tourney each year. In 2000, Tulsa went 32-5, setting a school season record for victories, and made it to the Elite Eight in the NCAA tournament.

His success at Tulsa led to his being named head coach at the University of Illinois on June 9, 2000. He guided the Fighting Illini to a 78-24 record over three seasons, including two Big Ten championships, a league tournament title and three straight NCAA appearances.

Roy Williams left Kansas after the 2003 season to take over at North Carolina, after which Self took over his "dream job" as the eighth head coach in Jayhawk basketball history. During Self's introductory news conference, KU chancellor Robert Hemenway handed him a coach's chair with Self's name on the back. Self grabbed hold and said, "It already feels hot."

In his first season, Coach Self led the Hawks to the Elite Eight. After coaching KU to a Big Twelve Championship the next season and a number three seed in the tournament, the Jayhawks incurred a very disappointing loss to number fourteen seed Bucknell. Again tying for the conference title in 2006, the number four seed Jayhawks dropped another disappointment to the number three seed Bradley Braves. Even so, his three-year record at KU was 72-24 (75 percent).

Winning the Big Twelve again in 2007, KU finally lost in the NCAA tourney to number two seed UCLA in the Elite Eight, finishing with a season record of 33-5. In 2008, he led the Jayhawks to their fourth straight Big Twelve conference title and began the NCAA tourney as a number one seed. After beating Portland State, UNLV, Villanova and Davidson, the Hawks

stomped Roy Williams's Tarheels 84–66 before defeating the Memphis Tigers 75–68 in one of the most dramatic national title games ever. KU won a school record of thirty-seven games while winning its third NCAA championship.

Kansas fielded good teams the next three years, compiling a 27-8 record in 2009, while grabbing a fifth straight conference regular season title and eventually losing to Michigan State 67–62 in the Sweet Sixteen. Self was named the 2009 National Coach of the Year. After winning the conference title again in 2010, the Jayhawks lost to Northern Iowa 69–67 in the Round of Thirty-two, finishing with a season record of 33-3. KU won the conference title again in 2011 and advanced to the Elite Eight in the NCAA tourney, where it lost to VCU, 71–61.

In what was deemed a rebuilding year after losing four starters from the 2011 team and having three of his top recruits deemed ineligible by the NCAA, KU surprised all in 2012 by winning its eighth straight Big Twelve season title, which led to a number two seed in the NCAA tournament. After an easy win over Detroit Mercy, the Jayhawks won close come-from-behind games against Purdue and North Carolina State before facing top-ranked North Carolina in the second meeting with former KU coach Roy Williams. KU ultimately turned a close game into an 80–67 rout and a spot in the Final Four. After defeating Ohio State 64–62, Kansas advanced to the championship game against Kentucky, which had defeated the Jayhawks 75–65 early in the season.

If it hadn't been for missing eleven layups and two dunks, KU might have beaten the top-ranked, heavily favored Wildcats. However, the Hawks couldn't overcome a large first-half deficit, losing the title game 67–59 and concluding the year with a 32-7 record. Self was again named Naismith Coach of the Year.

Jay Davis, a lifelong friend and former Edmund Memorial teammate of Bill Self, says:

> *He's got incredible charisma and a great work ethic. He has instincts about everything and his instincts are always right. He just has an uncanny ability to communicate with people, and he's always been blessed. Throw it all together and he just has something most people don't. He has a lot of things break his way because he's there to gobble up the grounder.*

In his nine seasons at KU, Self has coached four Big Twelve Players of the Year and forty-two all-conference performers, leading the Jayhawks to

an outstanding record of 274-53 (83.8 percent). His home record at Allen Field House is 145-7 (95.4 percent) and currently holds a staggering 91-1 streak at the Phog.

## 2008 NATIONAL CHAMPIONS

*Kansas' comeback will be considered one of the greatest in the seven decades of NCAA championship games.*
*—Mike DeCoursey*

With all due respect to its many great teams, there are a number of reasons why it could be argued that the 2008 Jayhawks were the best in the 110 years of storied history of Kansas basketball. Aside from winning the school's fifth national championship, they won a school-record thirty-seven games and had an all-time high of five players chosen in the NBA draft.

After many heartbreaking NCAA losses since the 1988 national championship, KU at last won the big one twenty years later. From Roy Williams's third team in 1991 through 1998, the Jayhawks had an annual series of disappointing NCAA tournament losses, including all three years they were led by Raef LaFrentz and Paul Pierce, followed by Final Four losses the two final years for Kirk Hinrich and Nick Collison.

So perhaps KU was due, but it definitely had the horses in 2008 to take it all. It returned thirteen of fourteen letter winners, four of five starters, from a very strong 2007 team. Led by a core of five seniors, the Jayhawks returned 85 percent of their scoring, 80 percent of their rebounding and 86 percent of the minutes played from the 2007 squad, which finished 33-5.

In this electronic age, there is so much information available regarding the magical 2008 season, which culminated in the national championship for the Jayhawks, that I could hardly do justice to try and repeat it all.

For complete coverage of the championship year, one only needs to go to the official KU Athletics website, and the *Lawrence Journal-World's* website, KUSports.com, has excellent coverage called "Self-Made Champions." And of course, there are literally thousands of images on YouTube and hundreds of thousands of hits when you Google a search.

To briefly recap, though, Kansas opened the season on a 20-0 run, including some victories over national powers and its 600th win in Allen

Field House. After a short mid-year slump with three losses, all away games, the Jayhawks then went on a season-ending thirteen-game streak, capturing their 51$^{st}$ conference title and the NCAA championship.

KU had arguably the best back court in the country, with six-foot-one junior Mario Chalmers, six-foot-one senior Russell Robinson and five-foot-eleven sophomore Sherron Collins, with Senior Rodrick Stewart serving as an able backup. One could make the same claim for the frontcourt, led by six-foot-six swingman All-American Brandon Rush, the team's leading scorer. He was helped by a trio of bigs, including six-foot-nine Darrell Arthur, six-foot-eight power forward Darnell Jackson and six-foot-eleven center Sasha Kaun.

After the regular season, with KU winning its fourth straight league crown, KU won the Big Twelve tournament title in a classic match against top-seeded Texas. They then began their NCAA title run as a number one seed, defeating Portland State 85–61, followed by a romp over UNLV, 75–65, to advance to the Sweet Sixteen. Then they dismantled twelve-seed Villanova, 72–57, before edging by Cinderella Davidson, 59–57.

The Final Four included all four number one seeds, the first time that ever happened. KU faced top-seeded North Carolina in the semifinal and raced to an improbable 40–12 lead in the first half, and after a strong comeback by the Tarheels, the Jayhawks re-took control and claimed an 84–66 victory. Freshman Cole Aldrich, a six-foot-eleven center, was particularly helpful in that game, matching up against North Carolina's national Player of the Year, Tyler Hansbrough.

Against Memphis in the title game, it looked like KU was going to have another disappointing tournament-ending loss, lagging behind 60–51 with only 2:12 remaining. However, in what many call the best comeback in NCAA history, the Jayhawks tied the game in regulation on "Mario's Miracle" shot with 2.1 seconds left, sending the game into overtime, where KU took control and won 75–68. "I thought it was going in when it left my hands. It felt pretty good when I released it. I'll let everybody else talk about history. I just think it was a big shot," Chalmers said.

Another huge play was Collins's steal and three-pointer just before the end of regulation, and a lot of credit throughout the game went to Darrell Arthur, who finished with twenty points and ten rebounds.

Chalmers was named the Final Four Most Outstanding Player and was joined on the Final Four All-Tournament team by Arthur.

It's fun to note that all four living Kansas basketball coaches were in the Alamodome to witness the win. Roy Williams, notably wearing a Jayhawks

sticker, sat about ten rows behind the Kansas bench. Larry Brown, who coached KU to its last title, and Ted Owens also sat in the best seats given to KU fans. After it was all over, coach Bill Self, who had the best seat, said, "I don't know if a coach really deserves what happened to me, because I can't imagine it being any better at any time."

Mario Chalmers's historic shot. Lawrence Journal-World *photography by Nick Krug*

## MARIO CHALMERS (PLAYER: 2006–08)

Based on his recent success as the starting point guard for the two-time NBA Champion Miami Heat, in addition to his great success at KU, I believe that Mario definitely warrants the designation as a KU Legend.

After starring for Bartlett High School in Anchorage, Alaska, where he was named 4A State Player of the Year three times in a row and led his

team to two state titles, six-foot-two Mario was named a McDonald's All-American. He was coached by his father, Ronnie, who joined Mario in Lawrence as KU's director of basketball operations.

Mario became the starting point guard for KU mid-season his freshman year and was named the Most Outstanding Player of the Big Twelve tournament, selected to the all–Big Twelve Honorable Mention team, twice gained national freshman of the week honors and set the KU and Big Twelve freshman steals record with eighty-nine, while leading the Jayhawks to a first-place finish in the conference, and an overall record of 25-7, before the team lost the first game in the NCAA tournament to Bradley.

His sophomore year in 2006–07 was even more successful, again leading KU to the conference title and a 33-5 overall record, ranking second on the team in scoring, breaking the KU season record for steals with ninety-seven and directing the Jayhawks to three wins in the NCAA tournament before losing to UCLA in the regional final.

His last year at KU was just a blast, from start to finish. He again tied his KU season record for steals, set the KU career record for steals, averaged 12.8 points per game and led the team in assists per game and three-point shooting accuracy. He led KU to the conference title again for the third year in a row, scored thirty points in KU's win over Texas in the conference tourney and, of course, helped his team win the 2008 NCAA Championship with a three-point shot with 2.1 seconds left in the final game (often referred to as Mario's Miracle). His three just before the end of regulation brought the game into overtime, when Kansas would take over and beat the Memphis Tigers. Mario was named Most Outstanding Player of the tournament. "It will probably be the biggest shot in Kansas history," KU coach Bill Self said. "Just remarkable that a guy can have that much poise when the pressure's on like that."

Known for his consistency during his three-year career at KU, Chalmers averaged 12.2 points per game, while giving 3.8 assists per game, making 2.6 steals per game and grabbing 2.8 rebounds.

He was drafted with the thirty-fourth pick of the 2008 NBA draft by the Minnesota Timberwolves, who later traded him to the Miami Heat. He has been the starting point guard for the Heat during the last five seasons, averaging 8.4 points per game.

On December 9, 2011, Chalmers re-signed with the Heat to a three-year, $12 million deal. Statistically, he had his best regular season with career highs in both three-point percentage and field goal percentage.

CHAPTER 12

# MOST HONORABLE MENTION

In addition to the players and coaches cited in chapters one through eleven, there are a number of other Kansas University basketball Legends worthy of considerable mention due to their outstanding contributions.

> *The Kansas tradition is so overwhelming that not only is the Basketball Hall of Fame in Springfield, Massachusetts, named for Naismith, but it includes eight Jayhawk players and coaches—more than from any other school. Indeed it seems that almost everything that matters in the sport is somehow connected to the school.*
> —*From* Sports Illustrated, *February 13, 1978, by Larry Keith*

Actually, there are now seventeen KU representatives in the Hall of Fame—still more than any other school in the United States. All are noted as KU Legends in this book.

## JOHN B. MCLENDON JR. (STUDENT: 1933–36)

*John B. McLendon Jr. was much more than just a highly successful basketball coach. He was one of those individuals whose remarkable courage, unswerving determination, and moral strength in the pursuit of human rights and social justice brought democracy in America a step closer to reality.*
—*Author Milton S. Katz*

John McLendon was born on April 5, 1915, at Hiawatha, Kansas. His father was a professor at Washburn University. McLendon was part African American and part Delaware Indian from his mother's side. His mother died in the 1918 flu pandemic, which led to the temporary breakup of his family. John and his younger brother Arthur were sent to be with his Delaware Indian grandparents on a ranch near Trinidad, Colorado, while his older sister, Anita, was sent to be with an aunt in Omaha, Nebraska, and his younger sister, Elsie, was sent to other relatives but would end up with a foster family on a ranch in Idaho. The family was later reunited after John's father remarried in Kansas City.

An all-around athlete and excellent student, he graduated from Sumner High School in Kansas City, Kansas, in 1932. After a year at Kansas City Junior College, where he made the basketball team, he transferred to the University of Kansas, where he was one of only sixty black students. At KU, he did not actually play basketball, as the KU varsity team did not accept African Americans then. Although it seems inconceivable today, in the 1930s blacks were not allowed on most college and professional teams. However, he acquired knowledge and skills of basketball under the tutelage of Dr. James Naismith.

McLendon recounted:

> *My father told me about Kansas University and some of the problems I might run into as a black student in 1933. When he took me to school, he told me to go find Dr. Naismith. My father said, "Tell him that he's to be your advisor." I did just that, and Dr. Naismith said, "Who told you this?" "My father," I said. "Fathers are always right," Dr. Naismith said. Many of my doubts about being at Kansas were quickly dispelled by Dr. Naismith, who treated me courteously and attentively and made me feel comfortable in my surroundings as a new student.*

As the first black physical education student, it was difficult for McLendon to line up a practice teaching position at segregated white schools, as the prevailing attitude at that time was that white students were not to be taught by black teachers. But Naismith used his influence to line McLendon up to do his practicum at Lawrence Junior High, where he taught gymnastics, and at Lawrence Memorial High School, an integrated school with separate white and black teams, as an assistant basketball coach. In his senior year, he was named head coach of the black team at Lawrence Memorial.

McLendon received a BS degree from the university in 1936, becoming KU's first African American student to obtain a degree in physical education.

After coaching at Lawrence Memorial for two years, he then went on to earn an MA in physical education from the University of Iowa in 1937.

## College Coaching

"Coach Mac" accepted his first college position as assistant basketball coach at North Carolina College (later North Carolina Central University). As its head coach from 1940 to 1952, he led his team to victory in eight Central Intercollegiate Athletic Association (CIAA) tournaments, winning four consecutive league tournaments (1949–52). Among the players he coached at NCC was Harold Hunter, the first African American athlete to sign with the NBA.

McLendon was a consummate gentleman who waged a continual fight to break down barriers of racial segregation. His creative and courageous efforts to break through the color lines of institutional racism include the famous "secret game" between his North Carolina College players and the Duke University Medical School in 1944, the first collegiate basketball contest where blacks and whites competed on the same floor.

McLendon then moved to Hampton Institute (Hampton, Virginia), where he served as head basketball coach, assistant football coach and physical education professor from 1952 to 1954, taking the basketball team to its best record in twenty-six years.

In 1954, he became head coach of Tennessee A&I State University in Nashville. During his six-year tenure there, the Tigers broke new ground for African American athletes and set unprecedented college basketball records. The year 1954 marked the first time a black college was invited to play in a tournament of the National Association of Intercollegiate Athletics (NAIA). Newspapers of the day reported that it was also the first time that blacks were allowed to stay in the downtown Kansas City hotels. When the Tigers took the 1954 title, McLendon became the first African American coach to win an integrated national championship. His team went on to win the tournament in 1957, 1958 and 1959, making him the first coach in history to win three consecutive NAIA championships.

After a four-year stint at the professional level, he returned to college basketball in 1963 as head coach at Kentucky State. In 1966, he went to Cleveland State, becoming the first African American head coach of a predominately white university.

He was an early pioneer of game preparation, conditioning, the fast break, the full-court press and a two-corner offense that became the seed for Dean Smith's famous four corners offense. Milton Katz, in his biography of McClendon, reported, "Here was a man that was never whistled for a technical during his entire coaching career. According to many of his players, he never used profanity and never raised his voice."

McLendon's on- and off-court accomplishments paved the way for black colleges, black coaches and black athletes to compete and succeed on both the collegiate and professional levels. In fact, nine years before Texas Western captured the NCAA championship in 1966, McLendon's black college squads from Tennessee A&I University defeated more than a dozen white teams from throughout the United States, including the South, to capture three consecutive NAIA national championships.

## *Pro Coaching*

McLendon left Tennessee A&I in 1959 to become head coach of the Cleveland

Pipers, an AAU team of the National Industrial Basketball League. He was hired by owner George Steinbrenner (yes, the same George who went on to own the Yankees). When the Pipers joined the American Basketball League (ABL), McLendon became the first African American head coach of a professional team and led the Pipers to the league championship in the Eastern Division in 1962. That same year, McLendon was fired by Steinbrenner when he refused to tell a player that he had been traded to another team— that night's opponent.

John McLendon. *Internet, source unknown.*

In 1969, McLendon was hired by the Denver Rockets. After a brief stint with the Rockets, McLendon ended his twenty-five-year professional coaching career with a winning percentage of 76 percent, a lifetime total of 523 victories and 165 losses.

## *Olympic Coach and Advisor*

McClendon was the first black coach on the USA Olympic team in 1968 and the first African American to serve on the U.S. Olympic Committee. He coached the USA's Olympic team in 1972 and remained a scout for the Olympic and Pan American Games until 1976. During the 1980s, McLendon was an international promotional representative for Converse Rubber and conducted basketball clinics around the globe. He authored two books: *Fast Break Basketball: Fine Points and Fundamentals* and *The Fast Break Game.*

## *Honors*

McLendon's professional honors include 1948 CIAA Coach of the Year, 1946–55 CIAA Coach of the Decade, 1955 CIAA Coaches Award, 1958 NAIA Coach of the Year and NAIA Hall of Fame, 1962 Helms Hall of Fame Award, 1977 Metropolitan Award from the New York Basketball Writers Association, 1977 Distinguished American Award by the North Carolina Central University Alumni Association and a 1976 special award for the development of international basketball. In 1978, he was inducted into the CIAA Hall of Fame, and in 1979, he was enshrined in the Naismith Memorial Basketball Hall of Fame along with Wilt Chamberlain. The first African American college coach to be so honored, McLendon was cited as "the acknowledged leader of the emergence of Black colleges into the varied national programs." In that same year, he was elected to the National Sports Hall of Fame and the Black Hall of Fame as well. In 1992, Cleveland State named its new basketball arena in McLendon's honor, and *Sports View* magazine selected him Coach of the Century.

The National Association of Collegiate Directors of Athletics maintains the "John McLendon Memorial Postgraduate Scholarship" program, giving five scholarships annually to help minority students pursue careers in athletic administration at the collegiate and pro levels.

McLendon received doctoral degrees in humane letters from North Carolina Central University (1977) and Jarvis Christian College (1978). He died on October 8, 1999. Notwithstanding McLendon's coaching legacy and its impact on the game of basketball, he was inducted into the Naismith Memorial Basketball Hall of Fame only as a "contributor," not as a coach. He was, however, selected in 2007 for the second entering class of the National Collegiate Basketball Hall of Fame for his coaching achievements.

His amazing career culminated in his efforts as a basketball ambassador; he traveled to fifty-eight countries, teaching the fundamentals of the game and the value of sportsmanship, and many believe he contributed more to the proliferation of basketball worldwide than any other individual.

A biography of John B. McLendon, *Breaking Through: John B. McLendon, Basketball Legend and Civil Rights Pioneer*, by Milton S. Katz, was published in 2007. McLendon's coaching legacy is also chronicled in the documentary *Black Magic*, which originally aired as a two-part series on ESPN in March 2008.

## LYNETTE WOODARD (PLAYER: 1978–81; ASSISTANT COACH: 1999–2004)

*As an athlete, I am relentless energy.*

KU's Lynette Woodard was simply the best and most successful female basketball player ever.

## *Growing Up*

Lynette was born on August 12, 1959, in Wichita, Kansas. The Kansas State Historical Society reported that she "started shooting with a stuffed sock when learning basketball from her brother and by age ten she was in demand as a neighborhood basketball team member."

At age sixteen, Woodard joined the varsity team at Wichita's North High School and led the team to two state championships. As a senior on April 4, 1977, Lynette sank a twelve-foot jump shot with four seconds left, leading North High past previously unbeaten Hutchison, 54–53, in the finals of the State 5-A basketball tourney. In the three-game event, she scored 113 points.

During her high school career, she scored 1,678 points and collected 1,030 rebounds in just sixty-two high school games. In recognition, she was inducted into the National High School Sports Hall of Fame.

## At KU

Woodard then went on to play college basketball at Kansas University from 1978 to 1981, when she was one of few athletes in the history of NCAA competition in any sport to be named All-American for all four years of her collegiate career. A superstar from the day she became a Jayhawk, she hit an incredible 52.2 percent of her shots, averaged 26.3 points per game and scored 3,649 points during her four years there; she was also the first KU woman to be honored by having her jersey retired. Despite playing her college career without the three-point shot and the smaller women's basketball, the six-foot Woodard scored over 400 points more than any other woman in Big Eight history and also set the conference rebound record, with 1,716.

In 1981, she was named the Wade Trophy winner as the outstanding female basketball player in the nation and remains major college basketball's career women's scoring leader.

## Olympics

In 1984, she was the captain of the United States' women's basketball team that captured the gold medal at the Los Angeles Olympic Games.

## As a Professional

Upon graduation from the University of Kansas, Woodard was recruited to play in the Italian women's professional basketball league, where she starred. In 1985, Woodard made headline history when she became the first woman ever to play with the world-famous Harlem Globetrotters. The news coverage of this event gave her much attention, and the fact that she traveled to many countries worldwide with the Globetrotters helped women's professional teams from many different parts of the world take notice. She participated as a full member of the Globetrotters entourage, being involved in their array

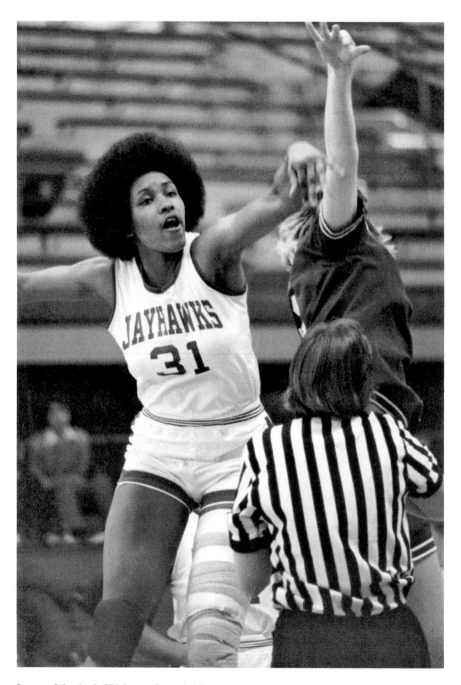

Lynette Woodard. *KU Spencer Research Library.*

of comedy and basketball tricks. Incidentally, Woodard's cousin, Hubert "Geese" Ausbie, also played for the Globetrotters from 1961 to 1985.

In 1987, after her tenure with the Globetrotters, she returned to Italy, where she played professionally for an additional two seasons and led the league in scoring. In 1990, she was signed by a Japanese women's team and played there until 1993. She then served as athletics director for the Kansas City, Missouri School District for two years.

At the age of thirty-eight in 1997, fulfilling a life-long dream, she joined the Cleveland Rockers of the newly founded Women's National Basketball Association (WNBA). The following year, she was selected in an expansion draft by the Detroit Shock.

### Later

After retiring from basketball, she began working as a stockbroker in New York City. In 1999, she returned to the University of Kansas to serve as

Lynette Woodard. *KU Spencer Research Library.*

the assistant coach of the women's basketball team. In late January 2004, she was named interim head coach, filling in for the regular coach, Marian Washington, who had retired for medical reasons.

## Honors

Her natural athleticism, leadership and floor sense were the attributes that separated Woodard from her contemporaries. In 1996, she was named by unanimous vote the greatest female player in Big Eight Conference history. Subsequently, she was inducted into the National High School Sports Hall of Fame, the GTE Academic Hall of Fame, the University of Kansas Athletic Hall of Fame and the Kansas State High School Activities Association Hall of Fame.

In September 2004, she was inducted into the Naismith Basketball Hall of Fame in Springfield, Massachusetts. And in June 2005, she was inducted into the Women's Basketball Hall of Fame in Knoxville, Tennessee, and later named by *Sports Illustrated* magazine as one of the greatest athletes in the history of the state of Kansas.

## Current

Woodard now works as an investment advisor and lives in Houston, Texas.

## MAX FALKENSTIEN (BROADCASTER: 1947–2006)

When it comes to KU Legends, it's hard to top broadcaster Max Falkenstien, who was behind the microphone calling KU games for six decades.

It's been reported that Max shies away from the word "legend," saying, "Legend is a hard word to know what it means. I don't know if it goes to someone who's been around so damn long, or if they just enjoyed the work they've done." Either way, Max qualifies.

## *Starting Out*

Max was born on April 9, 1924, in Lawrence, Kansas, the son of Earl and Edith Falkenstien. His father was business manager of the KU Athletic Department for thirty-three years. "That was my entryway into KU athletics," Falkenstien said. "My dad knew all the athletes, and I'd go to Robinson Gym and he'd introduce me to them."

Max attended Liberty Memorial High School in Lawrence, where his career actually began when he went on a field trip to the University of Kansas. It was a journalism excursion to learn and practice radio broadcasting. A teacher told Max he had an amazing voice, and she recommended he try his hand at broadcasting.

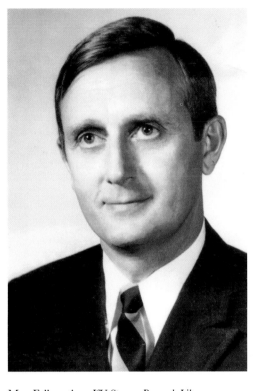

Max Falkenstien. *KU Spencer Research Library.*

As a junior in high school, he heeded that advice. He walked into WREN, then a Lawrence radio station, and asked for a job. "A guy named Earl Bratten gave me some news copy to read and I got the job," Falkenstien said. He worked before and after school and on weekends, usually forty hours a week, and earned ninety dollars a month.

After high school, he joined the U.S. Air Force, and after three years he returned to Lawrence, enrolled at Kansas University and returned to work at WREN. "Once I came back, I knew radio was what I wanted to do. The station manager said, 'There's a big basketball game next week in Kansas City and I think we ought to carry it and do you want to do it?' I said, 'Well, I've never done a game,' but I was willing to give it a try." So at age twenty-one, he broadcast his first college basketball game between Kansas and Oklahoma A&M in the 1946 NCAA tournament. "When I got back to school and went to class the following Monday, my mathematics professor and several others said they really enjoyed

the broadcast of the game Friday night. They said, 'It sounded like we were right there and we were a part of it and you did a great job.'"

WREN decided shortly thereafter to broadcast KU football for the first time. "They asked me if I wanted to do it, and I said, 'Let's give it a try.' And the first game I did was a nothing-to-nothing tie with TCU."

## *Broadcasting Career at KU*

His career at KU spanned six different decades, which included nine football coaches, five basketball coaches, eight bowl games, nine Final Four appearances, four conference affiliations and ten athletic directors.

Sixty years and more than 1,750 basketball broadcasts and 650 football broadcasts later, Max broadcast his final home game when Kansas played Colorado in Allen Field House on March 1, 2006. He served as the play-by-play voice of the Jayhawks for thirty-nine years and switched to the commentator's role in September 1984, when Bob Davis assumed the play-by-play duties. Amazingly, he called every single men's basketball game played in Allen Field House.

Max also made his mark on television along the way. He provided the play-by-play on the Big Eight Conference men's basketball Game of the Week between 1968 and 1971. And for more than three decades, he hosted football and basketball coaches' television shows, including those for Don Fambrough, Pepper Rogers, Mike Gottfried, Ted Owens, Larry Brown and Roy Williams.

Actually, Falkenstien has had two full-time careers. He was program and station manager of WREN radio from 1955 to 1967, and he was head of news and sports at WIBW radio and television for four years after that. Then after a one-year stint as the first general manager of Sunflower Cablevision, Falkenstien spent twenty-two years at Douglas County Bank, retiring as a senior vice-president.

His final broadcast at Allen Field House came on March 1, 2006, the last home game of KU's season. Max was honored during an emotional halftime ceremony, when a commemorative number sixty jersey was unfurled in the south rafters of Allen Field House, symbolizing his sixty years as the "Voice of the Jayhawks." The retirement ceremony made him the twenty-seventh basketball person so honored by the university, the first non-athlete.

No matter where the road took Max, he always found his way home to his wife, Isobel. The couple has two children, three grandchildren and one

great-grandchild. Max said life on the road was not taxing on his family matters. The great-grandfather said he traveled for four or five football games a year and about fifteen road basketball games. He said he always looked forward to going home but enjoyed sightseeing along the way.

The title of his latest book is *A Good Place to Stop, 60 Seasons with Max and the Jayhawks*. He has not disappeared completely from the Jayhawk nation, as he joined the KU Athletics Department after retiring from broadcasting, working directly for athletic director Lou Perkins on special assignments. And he still works part time at the bank, does some public relations work for Brandon Woods Retirement Center and plays racquetball and golf as often as he can.

## *Honors*

Falkenstien is one of the most decorated broadcasters in sports history. The Naismith Memorial Basketball Hall of Fame and the College Football Hall of Fame have both honored Falkenstien as a member. He has been inducted into the Kansas Sports Hall of Fame and the KU Athletics Hall of Fame and was the first inductee of the Lawrence High School Hall of Honor. In addition, he has been awarded an honorary "K" by the K Club, which includes all varsity male and female athletes.

The *Sporting News* in 2001 named Falkenstien "the best college radio personality in the country." He was honored by the College Football Hall of Fame with the Chris Schenkel Award for Broadcasting excellence, awarded the Distinguished Service Award by the Kansas Association of Broadcasters, given the Lifetime Achievement Award from Baker University, won the Fifteenth Annual Curt Gowdy Electronic Media Award from the Naismith Memorial Basketball Hall of Fame and received the Ellsworth Medallion— the highest award of the KU Alumni Association.

On January 25, 2007, Falkenstien received another award as he was named Kansan of the Year by the Native Sons and Daughters of Kansas, which was formed to preserve state history. He is a member of the Kansas Broadcasters Hall of Fame and was the first appointee of Governor Mike Hayden to the State of Kansas Sports Hall of Fame Board of Trustees and served as chairman of the board for eight years, from 1988 to 1996.

## ANDREA HUDY (KU'S ASSISTANT ATHLETIC DIRECTOR FOR PERFORMANCE, MANAGER OF ANDERSON FAMILY STRENGTH AND CONDITIONING COMPLEX, 2004–PRESENT)

Hudy is currently the only female strength and conditioning coach in men's Division I basketball and is KU's "Secret Weapon," according to former KU center Jeff Withey.

Andrea grew up in Huntingdon, Pennsylvania, the daughter of two high school teachers and coaches and the youngest of five athletic siblings: "My first sport was pee wee football. My dad was the coach and it was all boys, but at age eleven and twelve, I was the biggest kid there." Hudy mowed lawns in junior high and, in high school, worked at a local marina and cleaned boats on the side while competing in three sports. With no workout facility in town, her father, Richard, built a makeshift weight room under the patio at their home, including a squat rack, bench press, pull-up bar—the works.

Hudy helped her oldest brother train in football off-season by hopping on his back during resistance climbs up Appalachian trails.

She went on to play volleyball at the University of Maryland, where she graduated with a degree in kinesiology. "I think I was a better athlete than I was a volleyball player." By the time she graduated, she knew she wanted to turn her passion for strength and conditioning into a profession.

A stint in corporate fitness followed—something that Hudy now says she hated. Convinced that working with college athletes would be a better fit, she returned to higher education with a graduate assistantship at the University

Andrea Hudy at the Anderson Family Complex. Lawrence Business *magazine*.

of Connecticut. When UConn basketball coach Jim Calhoun was informed that Hudy had been hired to oversee his team's strength and conditioning program, he placed a call to his wife, saying, "Guess what? We've got a female strength coach. That will last about two weeks."

But at UConn, Hudy quickly made an impression on strength and conditioning coach Gerald Martin. "She had an intensity that rivaled all strength coaches. The athletes she worked with forgot about the fact that she was a female and believed that she could probably kick their asses if they got out of line."

At UConn, she helped coach two men's basketball, five women's basketball and one men's soccer team to national championships while earning her master's degree in sports biomechanics. While there, she teamed up with a kinesiology professor named William Kramer and studied a training philosophy known as nonlinear periodization, ground-based functional strength and power training (explosive exercises that mimic players' movements on the court). Former Huskie and current Detroit Piston Ben Gordon was quoted as saying, "There's no question she had as much to do with us winning the 2004 national championship as anyone." When it came time to cut down the nets at San Antonio's Alamodome, everyone made sure Hudy got a strand.

Bill Self was even more pessimistic about Hudy when then Kansas athletic director Lew Perkins suggested he hire Hudy. "I didn't want to hire her," Self said. "Lew would say, 'If you just meet her once, you're going to love her.' But I kept saying, 'I don't want to hire a woman to be a men's strength coach. Who does that?'"

If it weren't for some cajoling from Perkins, who had come to KU from Connecticut the year before, the move might not have occurred. But Self eventually met her, was impressed and hired her. Nine Big Twelve championships and three Final Fours later, he says that hiring her was one of the best decisions he's ever made. "I don't know where we'd be without her." Just as she did at Connecticut, Hudy has made a mammoth imprint in Kansas's basketball program. In the past seven seasons, no basketball team in America has totaled more wins than KU, including the national championship in 2008.

Of Self, Hudy says, "He's a great guy to work for. He's supportive and he lets me do my job. And there are very few coaches that allow strength and conditioning coaches or performing coaches to do their job and he gives me everything." Everything includes the new computer system inside the Anderson Family Strength and Conditioning Center on the KU campus.

It keeps track of every athlete's program and progress. It's a system so advanced, there are only ten like it on college campuses worldwide. Inside Kansas's sprawling weight-room, forty-two thousand square feet of squat racks and state-of-the art technology, Hudy can often find herself playing a range of different roles.

Recently, there has been significant collaboration between the marines and KU's Health and Exercise Science department. On July 10, she took a trip to Fort Leonard Wood, Missouri, discussing coaching and leadership with a group of marines. "The same things we deal with regarding younger athletes are the same things they deal with, with younger marines," Hudy said.

"Her visit was part of our ongoing, developing relationship with the Kansas University Athletic Department that started with their proposal to study our martial arts program and gather data related to athletic performance as it relates to memory and retention," said Colonel John Giltz, Marine Corps Detachment commander.

In January 2013, Hudy won the National Strength and Conditioning Association Coach of the Year Award. While Hudy may be rare as a female strength coach, Boyd Epley, founder of the NSCA, said, "She is best at what she does and you see the results on TV when you watch Kansas."

*"If I'm true to myself, and I trust the kids, and they know I'm honest and care, then how can you fail at that?" Hudy says.*

# BIBLIOGRAPHY

## BOOKS AND ARTICLES

Alexander, Chip. *Remembering Rupp*. Charlotte, NC: News and Observer Publishing Company, 1997.

Allen, Phog. *Better Basketball*. N.p.: McGraw-Hill Book Company, 1937.

Amdur, Neil. "John McLendon, 84, Strategist in College and Pro Basketball." *New York Times*, October 9, 1999.

Anderson, Ric. "Bud's Bunch the Best?" *Capital-Journal*, March 10, 2002.

———. "Memories of a Golden Age Still Untarnished." *Capital-Journal*, February 1, 2002.

*Augusta Chronicle*. "Blades Top Pick in WNBA Expansion Draft." February 19, 1998.

Barreiro, Dan. "Wilt Chamberlain: One of a Kind." *Minneapolis Star-Tribune*, October 13, 1999.

Basketball-Reference.com. http://www.basketball-reference.com.

Bechard, Harold. "An Interview With Max Falkenstien." *Salina Journal*, March 17, 1996.

Bedore, Gary. "Bridges Reconnects with KU." KUSports.com. December 10, 2004.

———. "Bridges to be Honored by Kansas." KUSports.com. January 18, 2002.

———. "Danny in Demand." KUSports.com. June 14, 2005.

———. "Falkenstien Has 'Jersey' Unfurled." KUSports.com. March 2, 2006.

———. "Former Teammates Laud Pierce." KUSports.com. June 1, 2008.

———. "Getting His Respect." KUSports.com. November 23, 2008.

———. "Naismith Never Exploited Game." KUSports.com. July 20, 2000.

———. "No. 13 Suits Wesley, Former Standout Has Jersey Retired." KUSports.com. December 19, 2004.

———. "Ray Evans Dies at Age of 76." *Lawrence Journal World*, April 26, 1999.

———. "Robisch Thrilled to Be Honored." KUSports.com. February 27, 2005.

———. "Stallworth Honored." KUSports.com. February 1, 2005.

———. "Stallworth to Be Honored at Halftime." KUSports.com. January 31, 2005.

———. "Valentine Honored by Jersey Hanging." KUSports.com. January 2, 2005.

———. "Wesley 'Excited' about Honor." KUSports.com. December 18, 2004.

———. "Wilt's Debut Can't Be Matched." KUSports.com. December 3, 2002.

"Bill Hougland: Two-Time Basketball Medalist." beloitchamberofcommerce.com/legend.html.

Bisheff, Steve. "Goliath of NBA Is Gone." *Arizona Republic*, October 13, 1999.

Brennan, John. "NBA Remembers Wilt." *Record*, October 13, 1999.

Chamberlain, Wilt. *A View From Above*. New York: New York Signet Books, 1992.

———. *Who's Running the Asylum? Inside the Insane World of Sports Today*. N.p.: Promotion Publications, 1997.

Chamberlain, Wilt, and David Shaw. *Wilt: Just Like Any Other 7-Foot Black Millionaire Who Lives Next Door*. New York: Macmillan, 1973.

Cherry, Robert. *Wilt: Larger than Life*. Chicago: Triumph Books, 2004.

Clarkson, Rich, ed. *The Kansas Century: 100 Years of Jayhawk Championship Basketball*. N.p.: Andrews Mcmeel Pub., 1997.

Colorado Basketball History. www.cubuffs.com.

*The Color of Life Is Red: A History of Stanford Athletics, 1892–1972*. Department of Athletics, Stanford University, 1972.

Cox, Forrest B. "Frosty." *Basketball Outline*. Boulder: University of Colorado, 1949.

*Crimson & Blue Handbook*. Wichita Eagle and Beacon Pub.

"Danny Manning Selected For 2008 National Collegiate Basketball Hall of Fame Class." ncaa.com. April 6, 2008.

DeCoursey, Mike. "In the End, KU Makes It Worth the Wait." *Sporting News*, April 7, 2008.

Deford, Frank. "Wilt Chamberlain: A Gentle Goliath." *Sports Illustrated*, October 25, 1999.

Diepenbrock, George. "Voice of the Jayhawks Is Top Kansan." KUSports.com. January 25, 2007.

Distinguished Alumni 1998. KU School of Business. dutch_lonborg.totallyexplained.com.

Eggers, Kerry. "Groomed for Success." *Portland Tribune*, April 6, 2007.

Elling, Steve. "Plenty of Time to Learn, Smith the Player Was Small, Slow." *News & Observer*, n.d.

Endacott Society. http://groups.ku.edu/~endacottsociety.

Evans, Harold C. "Baseball in Kansas, 1867–1940." *Kansas Historical Quarterly* 9, no. 2 (n.d.).

———. "College Football in Kansas." Kansas Historical Society, n.d.

———. "Some Notes on College Basketball in Kansas." May 1942.

Falkenstien, Max. "Falkenstien Book Gives Insider's Look at Kansas." KUSports.com. April 28, 2007.

Fitzpatrick, Frank. "And the Walls Came Tumbling Down." New York: Simon & Schuster, 2000.

"Former Kansas All-American O'Leary Dies at Age 90." KUSports.com, February 6, 2001.

# BIBLIOGRAPHY

Fox, Larry. *Illustrated History of Basketball.* N.p.: Grosset & Dunlap, 1974.

Fox, Sarah. "KU Great Honors King." KUSports.com. January 15, 2005.

Frankl, Ron. *Wilt Chamberlain.* New York: Chelsea House Publishers, 1955.

Freeman, Mike. "One of the Best Title Games Ever? KU Better Believe It." CBSSports.com. April 8, 2008.

Fulks, Matt, ed. *Echoes of Kansas Basketball: The Greatest Stories Ever Told.* Chicago: Triumph Books, ca. 2006.

Goering, Pete. "To Friends, Smith Still Is 'Smiles.'" *Capital-Journal,* n.d.

Goldstein, Richard. "Otto Schnellbacher, Two-Sport Star at Kansas, Dies at 84." *New York Times,* March 12, 2008.

Golen, Jimmy. "Pierce Thrilled to Be Part of History." Associated Press, June 1, 2008.

Goodson, Adrienne. "Lynette, Woodard: Will the Real Diva Please Stand Up?" slamonline.com. April 28, 2008.

Greenberger, Robert. *Wilt Chamberlain.* New York: Rosen Central, 2002.

Harris, Beth. "Friends, Family Recall Wilt's Humor." Associated Press, October 18, 1999.

*Harvey County Independent.* "Death of Adolph Rupp." December 1977.

Hastings, Carolyn. "Walt Wesley Steps Out of the Phog." *Cleveland Cavaliers News,* March 31, 2008.

Heisler, Mark. *Giants: The 25 Greatest Centers of All Time.* Chicago: Triumph Books, 2003.

Hendel, John. *Kansas Jayhawks: History Making Basketball.* N.p.: Walsworth Publishing Company, 1991.

Hersey, Mark D. "Touchdowns and Tragedy." Ms., Department of History, University of Kansas, 1945.

History of the American Basketball League. APBR.com.

"Hoopla: A Century of College Basketball, 1898–1996." Sportingnews.com.

Inductee in Wichita Sports Hall of Fame, 2004.

"In the Rafters." KUSports.com. http://www.kusports.com/intherafters.

Isaacs, Neil D. *All the Moves: A History of College Basketball.* New York: Harper & Row, 1975.

"James Naismith: A Kansas Portrait." Kansas State Historical Society, n.d.

Jenks, Jason. "The Rules of the Game—Bill Self, Kansas, and Basketball History." Grantland.com. March 16, 2012.

John B. McLendon Biography. "The Secret Game, Barack Obama and John McLendon, the Strange Death of Liberal America." February 25, 2009.

Johnson, Ken. "A KU Hero Dead at 90." HoopsZone.net. February 8, 2001.

———. "Oldest Kansas Basketball Letterman Passes Away." HoopsZone.net. February 6, 2001.

———. "Ralph Miller Dies at 82." HoopsZone.net. May 21, 2001.

Johnson, Roy S. "Far Above the Crowd." *Sports Illustrated,* January 26, 1981.

JoJoWhite.com.

Jorgensen, Eric. "'Long Story,' but Told So Well." *University Daily Kansan,* February 15, 2008.

Kansas Men's Basketball 2008–09. Media Guide.

*Kansas University Weekly,* November 13, 1897.

Keegan, Michael. "JoJo White: Real-Life Champion." *Northeastern Voice,* n.d.

Keegan, Tom. "Former KU Great Schnellbacher Dies at 84." *Lawrence Journal-World,* March 10, 2008.

# BIBLIOGRAPHY

Kerkoff, Blair. *Phog Allen: The Father of Basketball Coaching.* N.p.: McGraw-Hill/Contemporary, 1996.

Kerkoff, Blair, and Jeff Bollig. "A Century of Jayhawk Triumphs." March 2002.

Kirkpatrick, Curry. "One Man Show." *Sports Illustrated,* April 11, 1988.

———. "There's No Knock on Woodard." *Sports Illustrated,* July 23, 1984.

KU Athletics Department. http://www.kuathletics.com/sports/m-baskbl/specrel/index-08ncaa-champs.html.

KU News Bureau, comp. *Basketball at the University of Kansas.* Booklet, December 1937.

Lambert, Alan. "Thoughts on Hall of Fame Coach Ralph Miller." *Basketball Highway,* n.d.

Laughead, George, Jr. "Dr. James Naismith, Inventor of Basketball." Kansas Heritage.org.

*Lawrence Outlook,* "Another Honor for E.C. Quigley." March 15, 1956.

"Legendary Coach Ralph Miller Passes Away." www. OSUBeavers.com. May 16, 2001.

Libby, Bill. *Goliath: The Wilt Chamberlain Story.* New York: Dodd, Mead, 1977.

Lidz, Franz. "Is This Georgia Brown?" *Sports Illustrated,* January 6, 1986.

Litsky, Frank. "Ralph Miller, 82, a Hall of Fame Coach." *New York Times,* May 19, 2001.

"Lovellette Underrated." *Wabash Valley Profiles,* December 20, 2001.

Lunsford, Mike. "Warm up for Classic with Clyde Quiz." December 26, 2006.

lynettewoodard.com.

Mack, Will. "Home at Last." *Sports Illustrated,* March 10, 1997.

"Max Falkenstien Is Announced 'Kansan of the Year.'" KUSports.com. January 26, 2007.

Mayer, Bill. "Honest, Max Set Standard." KUSports.com. March 4, 2006.

———. "Hougland Can Relate to Thigh Bruise." KUSports.com. March 25, 2001.

———. "KU's Black Belongs in Hall." KUSports.com. January 23, 2005.

———. "Latest Biography about Chamberlain Could Be Greatest." KUSports.com. November 13, 2004.

———. "Plenty of Dirt on Rupp." KUSports.com. January 7, 2006.

———. "Ray Evans." KUSports.com. April 26, 1999.

———. "Wilt's Final KU Highlight Was Awe-inspiring Return." KUSports.com. April 3, 2004.

McClean, Tony. "Breaking Through: John B. McLendon, Basketball Legend & Civil Rights Pioneer." September 3, 2007.

McClellan, Michael D. "Amazing Grace, the Clyde Lovellette Interview." *Celtic Nation,* September 15, 2005.

———. "Power Point, the JoJo White Interview." April 7, 2003.

Murphy, Doyle. "Chamberlain Leaves $650,000 to Kansas." *Topeka Capital-Journal,* November 22, 2003.

Naismith, Ian. "The Best Sportsman I Ever Knew." NBA Encyclopedia, n.d.

Naismith, James A. *Basketball, Its Origin and Development.* New York: Association Press, 1941.

Nance, Roscoe. "Greatness with Celtics Judged by Titles." *USA TODAY,* January 12, 2006.

Nelson, Eric, and Laurette McMillen. *Crimson & Blue Handbook,* 1993.